Drylands, a Rural American Saga

Lionel Delevingne & Steve Turner

Drylands,
a Rural American Saga

UNIVERSITY OF NEBRASKA PRESS | LINCOLN & LONDON

Library of Congress Cataloging-in-
Publication Data
Delevingne, Lionel.
Drylands, a rural American saga / Lionel
Delevingne and Steve Turner.
 p. cm.
Summary: "A photoessay about life in
Adams County, Washington, a rural
farming area in eastern Washington"—
Provided by publisher.
ISBN 978-0-8032-3424-6 (hardback: alk.
paper) 1. Adams County (Wash.)—Social
life and customs—Pictorial works.
2. Farm life—Washington (State)—Adams
County—Pictorial works. I. Turner, Steve,
1937– II. Title.
F897.A2D45 2011
979.7'34—dc23
2011012633

Set in Scala.

For
Judith Wilkinson,
Anne M. Turner,
and the Good People of Adams County, Washington

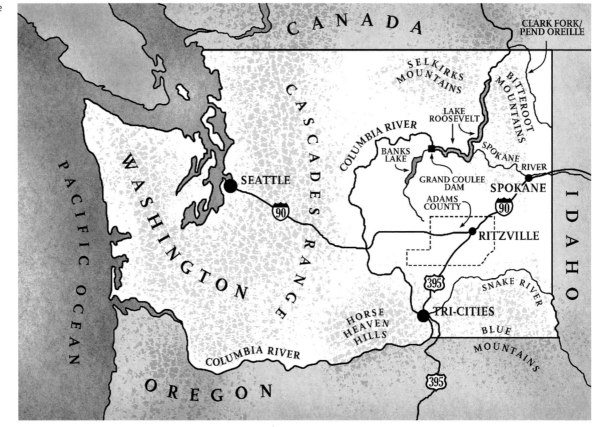

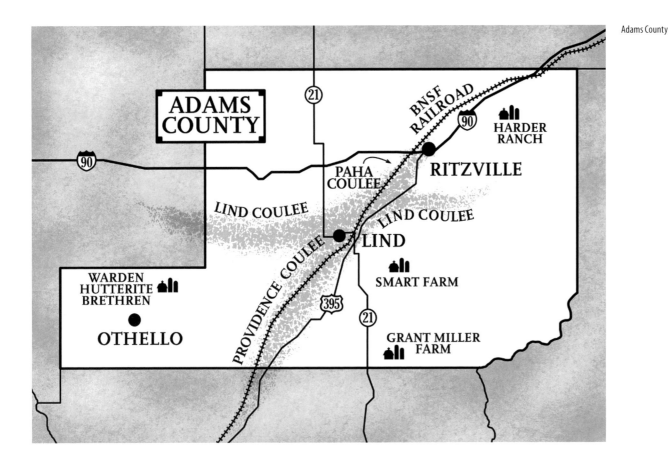

Contents

Introduction

"Old MacDonald had a farm: EE-I-EE-I-O."

Who didn't learn that song in elementary school? In America, the word "agriculture" evokes many different images, depending on where you live. But for big city folks in particular, there's always the cozy illustrations of the green, well-watered MacDonald family place, with its barn and tractor, cute chickens and friendly cow.

Ain't like that now. In 1900, farm residents were 42 percent of the American populace, and most—with a team of horses, not yet a tractor—lived Old MacDonald–scale lives.

By 2009? Fewer than 1 percent of families among us grow our food and fiber for eating or export. And although MacDonald-scale farming still exists, particularly in the east, where the nation began, the average size and operational scope of most remaining farms has grown almost exponentially: the total of crops produced in this country today far exceeds anything yester-year's larger mass of small family farms could yield.

In short, farms have grown fewer but larger, and, in the bargain, more productive. Mechanization, improved seed varieties, and soil-enhancing chemicals explain much of this statistical shift. But the educational evolution of the farmers themselves—the new MacDonalds, as it were—has a lot to do with it, too.

Yet, despite becoming more expert and better-equipped, family farmers still deal annually with considerable risk. Government backup supports are reassurance to growers of commodity crops, such as wheat, corn, and cotton, but offer no guarantee. Regardless of that help, two years of drought—or of swamping rains—can put even the most skillful of farmers out of business. And for those whose enterprises succeed, there are pains to pay for keeping up with the treadmill of modern mechanized agriculture—the propulsive dynamic of "get big, or get out"

There is another sort of pain, and irony, as well: as farms have grown larger, the towns founded to support them with supplies and services have shrunk.

As one farm wife and mother laments, for her son in college, "I really worry about him coming home to farm. Churches are closing, everything's closing. So how is he and his family—what is that going to look like when he lives here?"

It's the negative flip side of progress, the unforeseen impact of machinery's replacement of human and draft animal effort: reduction of farm families and farm labor. Not as many folks now locally buying clothes and groceries, medicine and supplies. Nor to sit in church pews. Nor to send children to school. Not near as many hired hands to populate the bars, the restaurants, the hotels.

Rural life in America is in continuing revision, and has been for some time. And yet out in farm country there is still an appealing resilience, a dedication to the art and science of growing crops, a commitment to neighborliness and a conviction that, yes, whatever hardships have descended, next year could be better.

No place offers a clearer example of the conflicting pressures of rural change than Adams County in east central Washington. Because, along with a full range of rural issues impinging on life in the croplands, this county features an adverse combination of weather and soil that makes it strangely both inviting and hostile to the plow.

Lionel Delevingne's intelligently artful camera gives us Adams County's vast and visually stunning landscapes—and evokes the good-natured hardihood of the people who make their lives in this challenging place. He visually links farmers and townspeople to the ground that sustains them both physically and spiritually, even as it demands the fullest possible attention of their patience, skill, and energy.

Success at growing crops here has a crucial, fundamental rule: adapt. In Adams County's drylands, particularly, that process definitely has aspects unique in American farming. But that very uniqueness adds weight to the prevalence here also of problems afflicting so much of the nation's agriculture.

The county sits almost like a centerpiece on the drylands of the Columbia Plateau. This rolling swath of land stretches downslope southwest from Idaho's bordering Bitterroot Mountains until it rounds out at eastern Washington's tri-cities: Richland, Kennewick, and Pasco. Its borders surround 1,930 square miles of a big rectangle with a curvy, stream-defined eastern end and a box-like extension out from its lower left corner. It's a place with drought-level rainfall, baking dry summers, subarctic winters, and dust-filled westerly winds persistent enough to drive you near crazy.

Even so, this difficult territory has become one of the nation's premier providers of wheat, potatoes, and cattle. Cereal grains grown here copiously ship to both the American and Asian markets. Spuds harvested and processed in Adams County yield a major share of the nation's french fries. And a goodly

supply of beef comes from cattle ranched in the county's eastern end.

This book illuminates the ambience from which so seemingly unlikely an outcome has emerged. Delevingne's photographs individually offer stories to the imagination, facts to the understanding, and contemplation of complex beauty in the land. But in composite they holistically depict the continuity and scope of productive life in a fascinating place—a place where unique meets commonplace in rural America.

The Eye of the Beholder

Ross Cox was one of the earliest non-Indians to see the place that became Adams County. He traveled through in 1812 with a party of fur traders, and his book, *Adventures on the Columbia River*, narrated that expedition. Suffice it to say, he did not admire what he saw:

> [N]o green spot bloomed around us. The country was completely denuded of wood; and as far as the eye extended, nothing was visible but immense plains covered with parched brown grass, swarming with rattlesnakes.

Enticing? Even the Native peoples who had prehistorically settled in the area, who hunted and gathered on these rolling arid plains atop the Columbia Plateau, didn't live there. Quite reasonably, they set their villages near the rivers that wreathed around and out from the plateau's dry interior: the encircling Snake and the Columbia, their tributaries reaching out and away, define the plateau's map with Adams County at its arid center.

Yet in America's nineteenth-century westward expansion, in the days of Manifest Destiny, even Adams County's drylands became a settlers' target. The story about how and why that happened is more than the simple epic of pioneers seeking new farmland. As elsewhere in the developing nineteenth-century west, immigrants were wooed here to settle by the railroads—the Northern Pacific, specifically, in the case of Adams County. As incentive to build, Congress had granted NPRR and the other lines opening the trans-Mississippi country considerable acreage along their trackways, which they then could sell. And they did. Advertisements touting the supposed wonders of the newly opened territories (notably failing to mention such items as low rainfall) went out nationwide and literally around the world. Among the eager immigrants who responded, some were fresh from overseas, some only on their next jump from earlier endeavors in the East and Midwest. When these settlers arrived, claimed land, and only then learned that in fact there was not enough precipitation to nurture an annual crop, they faced the farmer's reality: adjust, or quit.

Among those earliest arrivals, some were better prepared than others for Adams's semi-arid conditions. These were the "Russian Germans," descendants of farmers from Germany invited in the 1700s by

Catherine the Great of Russia to resettle in the eastern end of her empire, the Caucasus region above Turkey. Catherine chose these people because of their proven farming skills, hoping they would teach the Crimean peasants to bring better crops from that likewise under-watered place. To induce the relocation, she not only gave them land, she allowed them to keep German as their first language and, very important, exempted them from military service.[1]

When Catherine's successor, Czar Alexander II, rescinded that exemption in the mid-1800s, a time of considerable pan-European warfare, many of the resettled Germans elected to move on again.

One of their favored sites for new home ground was Adams County, familiarly dry but fertile like their former lands in the Caucasus. Along with their skills and persistence they brought a proven type of drought-resistant, hard red winter wheat, which came to be known locally as Turkey Red. It was the first variety of the grain that could predictably prosper in the dicey climate. Turkey Red saved the day for many early Adams County growers.

But adapting to Adams's very demanding growing conditions required more than just using favored brands of seed. Beyond that was the crucial lesson that fallowing acreage for a year—letting it absorb the average annual precipitation of usually nine inches or less (fifteen at minimum is the amount recommended for an annual crop)—was the only way to

prepare it for a full crop in the second year. In effect that meant successful farmers would need twice the land required for an equal annual harvest on better-watered land.

Some of the early emigrants could not prosper in these stringent conditions. But settlers who did succeed, who won their desired bounty from the soil, became—like the Native peoples they had displaced—admiring partners with their new home ground. In the way of things, the land possessed them as much as they possessed the land. And as their efforts bore fruit, they found visual charms here, too. Farmer Roger Smart describes the lovely effect of what happens when new seed heads appear atop the still green stems of ripening wheat, each head with its nimbus of hairlike extensions: "When those beards come out, in the late light the field turns to silver." Retired farmer Ruben Fode sees and feels the same: "In the spring, when the wheat is green and heading out, that's beautiful. Damn, I love that. The dirt's in my blood." Even without a burgeoning crop, says Fode, "This land has its own beauty."

Lionel Delevingne's photographs find that allure in many manifestations: the smooth, artfully curved patterns of plowing; the emphasis of roads, straight or twisting, evoking the terrain they run through; the supple overland flow of wheat; and, most fundamentally, the outcrops of basalt, the sere undeveloped spread of wild grasses, a bristle of sagebrush and

thistle—the native rock and foliage of this uniquely mounded terrain.

The land itself is subtly fantastic—a product of prehistoric, elemental forces that over millennia have churned and then comforted this ground into farmable soils. There was a time, some 24 million years ago in geology's Miocene Period, when this was semitropical territory. Dinosaurian creatures roamed here amidst foliage of the like seen now only in near-equatorial jungles. But the land was shifting, flowing however slowly atop the tectonic plates below. As that process wracked the geology, heaving up mountains and triggering unimaginably vast earthquakes, it opened great fissures in what's now northwestern Idaho—vents through which molten magma exploded in huge torrents that fell and spread red-hot lava in a fan reaching southwesterly to form the broad Columbia Plateau.

Over eons this happened more than twenty times. And between eruptions, abundant rainfall and resurgent plant life crumbled the basaltic lava's cooled surfaces into gravel and soil. Insects and animals returned, playing their parts in the proliferating plants' endless work of breaking the underground rock into smaller and smaller grains as their roots quested for nutrients.

Then, thousands of years later, and again and again in sequence after thousands more, other eruptions. The new flows of lava rolled over and compressed the renascent biology and its creation of soils and gravel—along with accumulated soaking of rainfall and streamflow—into what are now called interbeds, wet layers between impermeable densities of basalt.

But prehistory's assaults were far from over. Next came the Ice Ages, as the earth tilted and glaciers descended from the north. They never reached the Columbia Plateau, but their impact definitely did. Some 15,000 years ago, an extended finger of the Cordilleran ice sheet, which covered most of Canada and the northern United States, poked and froze south near the Idaho border, blocking the stream today known as the Clark Fork River. That dammed up drainage from a vast mountainous spread of today's Montana. The resulting confinement of water—retroactively called Glacial Lake Missoula—grew to be gargantuan. Extending eastward for 200 miles, it was up to 2,000 feet deep in places and contained some 500 cubic miles of water, equaling half the volume of Lake Michigan.

When the ice dam broke, a cataclysmic rage of water, more than the combined flow of all today's rivers on earth, surged violently out at the northeastern corner of the plateau and followed gravity's downslope pull to the south and west. Ridges in the land divided the vast flood into separate torrents that gouged deeply though the layers of basalt and their interbeds, creating huge coulees—ancient ditches up to 500 feet deep and a mile wide. (See image 20, for example. In that photo the four school buses are moving on

U.S. Route 395 along the bottom of the Paha Coulee.)

With its force funneled into the creation of these new channels, the roaring flood moved at speeds as much as 60 miles per hour with a 700-foot high front wall of slurry mud and ice. It unstoppably carved and excavated the landscape for 150 miles before pooling temporarily against the Horse Heaven Hills and high ground along the Snake River, creating what is historically known as Lake Lewis, which has long since disappeared. But back then this spreading inland sea reversed the flow of the Palouse, the Snake, the Columbia, and the Yakima rivers before finally forcing a vent through the barrier hills at Wallula Gap. Through that gap came rushing a deep, eager urgency of water so strong that it channeled the renowned Columbia River Gorge, carried icebergs bearing "erratic" boulders far downstream, reversed the flow of Oregon's Willamette River, and, meeting the ocean, chewed a still-discernible seabed trench that curves all the way to the northern tip of California. At the site of modern Portland, the flood crest was higher than any of that city's tallest buildings.

And once was not enough. As the big ice sheet advanced and withdrew over ensuing millennia, this cataclysmic scenario repeated itself numerous times. Each time, as the saturated land slowly recovered, the immensely fertile soil particles the glaciers had chewed out of Montana's mountains and alluvial soils were deposited downstream—especially so during the settling periods before Lake Lewis emptied through the Wallula Gap. With the water finally gone, the prevailing southwesterly winds went to work, blowing this fine-grained loess in a fan-shaped northeasterly spread. These Aeolian deposits mounded wonderfully fertile dirt hundreds of feet deep in much of Adams County, but more so in its eastern neighbor, Whitman County, home to the storied, better-rained Palouse country.

So it was that prehistory created the fine soils from which Adams County's farmers grow their crops. But the ice ages brought something even more significant for the full history of this place: humans. About 17,000 years ago, the expanding surge of glacial ice impounded enough seawater to significantly lower oceanic shorelines. Thus a land bridge between Siberia and Alaska was exposed. And the ancestors of the Native peoples of all the Americas began to come across.

Among them were the originators of the tribes that populated the Columbia Basin, with Adams County and its dry surroundings as a kind of shared expanse among them: the Cayuses, the Nez Perces, the Wallawallas, Palus, Yakimas, and Spokanes. With good reason these peoples anchored their settlements near the streams that feed the larger Columbia and Snake as those larger rivers encircle the basin. These tributaries' names, in fact, are all that remain of some of the local civilizations whose identities they memorialize. But for thousands of years they yielded harvests

of salmon, beaver, and other creatures that were basic to Native diets and apparel. Uphill from these life-giving streams, on the rolling drylands, the aboriginal people hunted antelope, deer, rabbits, and pheasant and dug the nutritious camas and bitterroot plants.

From time immemorial, trade routes connected these tribes with each other and with peoples as far distant as South America. Beads, precious metals, and horses came north. Furs and gemstones went south. When the likes of Ross Cox and his party arrived, anxious for beaver pelts in particular, they encountered a pattern of exchange that was already well established. But what the Natives didn't bargain for was the deadly invisibilities of European germs to which they had no immunity, and which decimated many of their settlements.

Nor were they ideologically prepared for the onslaught of settlers who wanted their territory for a purpose—to farm—that was beyond their ken. To the original inhabitants, the concept of individual ownership of land portions was unthinkable. Pressed by the U.S. Army to sell tribal acreage to settlers, the famed Nez Perce, Chief Joseph, replied that the earth is "too sacred to be valued by or sold for silver or gold. . . . The Creative Power, when he made the earth, made no marks, no lines of division or separation on it. . . . We love the land; it is our home. We will not sell the land. We will not give up the land."[2]

As farming settlers moved westward, though, urged and aided by the federal government, the Natives of the Columbia Basin were indeed forced to give up their homelands in exchange for protected status on reservations. (For some, such as the Cayuses and the Walla-wallas, the region's Indian wars essentially removed them from modern history.) This forcible transition put the land under control of the oncoming European peoples. In Adams County's dry climate, however, the newcomers discovered that in order to succeed they had to love and understand the soils they had acquired with as much dedication and intensity, albeit in a different mode, as had the Natives they displaced. Even among those who understood this necessity, more than a few found that the demands of the land and its climate were too strong to overcome. Survival of a farming enterprise here over the years has required not only skill but enormous persistence, and more than a little luck.

Latter-Day Beholders

I first came to Adams County in 1958, a college kid on summer break from school in the green, well-watered mountains and sumptuous valleys of Vermont. I was captivated by the difference. Some of the very scenery Ross Cox described was still on view—sagebrush, browned, dry grasses, parched thistles—and, in season, still is (see image 6, for instance). But Cox had not mentioned the appeal of the land itself, rolling voluptuously, often in almost feminine form, a

sensuous effect particularly noticeable when traversing in a vehicle (Cox and company, slogging along on foot and horseback, likely might have used more vindictive comparisons).

Of course, for me, in my long-after-Cox arrival, there was the wheat. Great spreads of it: tawny, toast-colored, looking both edible and sensual, pliable as the eddies of wind that pressed temporary fan shapes into it. That year I drove truck in the harvest around the central Adams city of Lind (a "city" by the state's definition, but at 400-plus residents, definitely not urban). It was an experience wonderfully unforgettable, even as life took me back east, then into the army overseas, then to graduate school. When I moved into journalism, I found assignments that sent me directly to the county, or near enough to visit. I returned to write a long article about the Columbia River, for instance, and again when the subject was the geology and geography of Yellowstone National Park. When the focus was small towns, I traveled cross-country with Lionel, and our reportage included Lind. Adams County captivated him, too. His eye loves the locale here just as mine does, and he exquisitely gives us the result in his photographs.

I realized eventually that my sometimes residential, sometimes reportorial attachment to this place spanned more than a third of its post-pioneer existence. Moreover, that period had encompassed some of the most significant changes in technology, land

tenure, and population shifts that have shaped the county's present and will undoubtedly shape its future. In 2009 I made bold to weave vignettes and highlights of local and regional history into a book, *Amber Waves and Undertow: Peril, Hope, Sweat, and Downright Nonchalance in Dry Wheat Country* (published by the University of Oklahoma Press). It's a narrative presented mainly by the voices and experiences of people who live or have lived and died in Adams County. Combined with my personal commentary, it is an anecdotal, living account that accentuates both the uniqueness of farming life here and the similarities so prevalent elsewhere in rural America.

Mechanization, for instance, has changed the nature of agriculture and its supportive social structure just as strongly in Adams County as it has almost everywhere in the nation's food-producing areas. The ever-improving machinery welcomed for its efficiency in working the land also very effectively began to reduce the rural workforce. Just so, the retail and service sectors of farmland towns began to shrink as well.

My 1958 harvest occurred at a kind of midpoint in that transition process in Adams County. The farmer I worked for—Bob Phillips, who had one of the county's larger spreads of land—was running three combined harvester machines, commonly known as "combines." Two were big red International Harvester units with cutter reels sticking out to the side and pulled by caterpillar tractors. The third was a more

modern evolution, a self-propelled unit, shiny in John Deere green, with all the cutting equipment up front.

The differences were far more than merely design, however. The older red International machines required a crew of two: cat skinner (the tractor driver) and the combine man, who rode atop that equipage, tending its vast variety of moving parts. The newer combines reduced the staffing need to one. This was a kind of final step in the process that began in the 1800s with horse-drawn machines that mowed the wheat, plus crews with wagons to collect and transport the severed stalks to threshing machines that lumbered from farm to farm on call.

Early combines cut out the need for grain-gathering and threshing crews, but their labor requirements were still significant. They were pulled by mules or horses (up to forty in some hitches), which needed hostlers and teamsters. The machines themselves had crews of five—driver, combine man, a header puncher (who managed the side-extending mowing apparatus), and two sackers. (A combine's mowing apparatus is called a header because its purpose is to snip and capture the business part of the wheat plant, the head and its grains.)

The unfortunate sackers rode miserably in surging dust on a platform just above the ground, filling and sewing shut the big sacks of threshed grain, which they dumped off for the following wagon to pick up.

So, a mere fifty years prior, Bob Phillips's harvest crew of eight—two cat skinners, three combine men, and three truckers to off-load the reapers—would have numbered at least twenty-one, not to mention the hostlers. The county's towns grew around those earlier numbers, all of them featuring hotels for itinerant hands. (In Lind, recalls a former service worker, the rates were painted on the windows "Rooms a dollar to three-and-a-half, and we used to laugh that, well, for three-and-a-half you got the sheets.") There were bars, brothels, eateries, and general merchandise stores, as well as hardware, fertilizer, fuel, equipment, and other farm supply enterprises. At planting and harvest time, particularly, men looking for work used to gather in the town parks, where growers would come to hire them on.

No more. Mechanization outmoded the need for migrant labor in grain farming. And it whipsawed many farmers as well. A grower needed to be successful in order to afford the new machinery—and, in order to justify the purchase, needed enough land to make the use of the new equipment profitable. Those whose endeavors had come up short in either dimension of necessity had to move on. Their abandoned homesteads (see images 8 through 15) dot the rolling farmland, evidenced by the raggedy survival of windbreak trees, the ghostly memories of once-hopeful families shushed by wheat crops surging right up to former flower beds and relict front stoops.

The survival dynamic for commercial farmers

evolved into a dilemma: get big, or get out. In the natural course of what was happening, successful growers acquired the land of departing neighbors. Result? The number of U.S. farms shrank from nearly 5.7 million in 1900 to 2.2 million in 2007, while their average size rose by 67 percent and agricultural production substantially increased. The corresponding shrinkage of farm family populations dealt a further misery to the commercial sectors of the towns that had grown to support a larger number of outlying residents. Images 59, 60, and 61 show the impact of this change in Lind and Ritzville, the county seat, both of which once sported bustling business districts.

So it went in Adams's predominant wheatlands. In cattle country, fringing the eastern edge of the county, technological change also has had its impact on ranching practices. But that impact has not included shrinkage of the stockherding population—which was small to begin with, albeit that beef is the county's second-largest cash crop. Most of Adams's ranch land is held in big parcels by descendants of three Harder brothers who emigrated from the Schlesweig-Holstein area of Germany in the 1880s. They brought with them homegrown skills in stock raising, and settled in to expand their experience. In the end they and their descendants owned land running through three counties—one of the largest contiguous ranching operations in the United States.

On a big sector of that range in Adams County, Jake and Joan Harder manage a herd of some six hundred Hereford and Hereford-Angus cattle. Jake cordially refers to his grain-growing neighbors as "stubble jumpers," and was chagrined to learn that a published and respected local history mentioned an earlier Jacob Harder who planted wheat. "Well, that was my grandfather," he drily observed, "and I tell you what, if you could make a penny, he probably did. As far as livestock, I don't think he ever had a herd of jackrabbits, but everything else: horses, sheep, and cattle. He stuck right with it."

The Harders got their horses initially through trade with the Palouse Indians, and drove them as far north as Alberta in Canada for sale. They ran large herds of sheep, moving them more than 100 miles from the spring greenery of the Adams drylands all the way to the backside of the Cascade Mountains for lush summer feeding, then returning to the coulees for winter. Even as the family enterprise shifted toward cattle, says Jake, "There were sheep run by my immediate family probably up until somewhere in the mid-1930s." But no more. "Markets get real ugly in sheep. Labor costs are pretty high. And coyotes are a never-ending nightmare in the sheep business."

As Jake himself found out. "I had one experience with sheep. When they get loose, they will travel. There were some ewes came traveling through this country, sometime in the sixties. They were just traveling along about mid-February. So I saddled up my horse

and went and gathered them up and brought them in. We just suddenly had this phenomenal little herd of sheep, and in four months the score was coyotes twenty-three, Jake nothin'. They just took them out."

Jake and his family depend on their experienced horses for herding, abjuring the "crotch rocket" all-terrain vehicles adopted by some ranchers. "A motorcycle doesn't have a brain, and these horses do. And boy do they get cagey. You'll be moving a cow along, and pretty soon the cow'll start off . . . it takes that horse maybe two steps and he knows which way they're going. Those old horses that've been at this all their lives, sometimes they'll just move their heads and turn that cow back. They don't even take steps, just move their head."

But when it comes to other changes in the technology of ranching, the Harders are on top of it. They no longer put up their own hay. ("Back in the seventies," says Jake, "I decided that I wasn't gonna be a slave to a damn hay baler all summer long." Instead, they buy alfalfa, corn, and milo to enhance their range forage.) Jake has won prizes for his adaptation of solar-powered pumps to fill water troughs out on the rangeland. The Harders no longer raise their cattle to full age for slaughter, but instead send them to feedlots to prepare for market. And when it comes to selling, they use the Internet—but only on websites restricted to the beef business. Laughing, Jake says, "You just don't want to put 278 steer calves on the web and have some college kids drunk on Saturday afternoon order them up."

Even with the Harders' innovations, the fundamentals of stock raising—the oldest form of agriculture introduced to Adams County—continue relatively unchanged. So also the skip-year fallowing in the farming of dryland wheat (albeit with production markedly improved by advances in methodology, seed improvement, mechanization, use of chemicals, etc.). But in the driest west end of the county, engineering and technology have spurred radical change in what's grown and what's done with the harvest. What was once mainly a dusty zone of parch-defeated dryland farms has become a wonderland of irrigation.

It was a set of deceptively good rain years around the turn of the twentieth century—a wet spell only later discovered to have been quite unusual—that persuaded immigrants to take a chance and settle in this area. They founded Adams's third city, Othello, in 1910. Why Othello? No one knows. Speculation suggests that Shakespeare's famous tragedy was a favorite of the first postmistress, but there's no proof. In any event, the town's only remaining connection to the Bard of Avon is three small streets named Desdemona, Macbeth, and Venice.

Nor is there any remaining evidence of the town's heyday as a division headquarters for the cross-country Chicago, Milwaukee & St. Paul Railroad, an all-too-fleeting highlight of history. The Milwaukee Road's

passenger service ended in 1961, the line went bankrupt in the 1970s and literally pulled up its tracks and tore down its buildings in 1980. Almost without exception, Othello's earliest structures consequently disappeared.

But the exhaustion and disappearance of the railroad occurred in a kind of serendipitous *pas de deux* with the arrival of water, which brought the potential for new crops to the area's farms. And those crops attracted processing plants that gave Othello a brand new industrial base. In a kind of only-in-Hollywood ending, this place, where desperate farmers had paid bogus "rainmakers" to blast ineffectual chemicals into the sky, became a beneficiary of one of Franklin D. Roosevelt's most important Depression-fighting public improvement ventures: the Grand Coulee Dam, and the Columbia Basin Irrigation Project that the dam supplied.

Beginning in the 1950s, canals brought "Coulee water" to the western reaches of Adams and its neighboring counties north and south. But just as important was the simultaneous onset of new irrigation technology in the form of center-pivot systems. These gawky arrays, for all the world like outsized erector set creations (see image 35), rotate wheeled, flexible spraying arms around the central pumped outlet of a deep well. So, while there was a limited spread of Grand Coulee's output by gravity flow systems, the new mechanical marvels—each able to spray almost

a quarter section, or 160 acres—could go in almost anywhere, pulling up groundwater to hit the dry spots left out of the Columbia Basin Project.

This fluid influx from both sources brought Adams and its neighboring counties the wherewithal to grow new crops—alfalfa, corn, beans, and, most significantly, potatoes. These tubers can only be farmed every three to four years on the same piece of land, in rotation with legumes and other soil-strengthening plants. Nonetheless, the abundance of their harvest and their cash value at market has made them the county's top agricultural money-earner.

That is true mainly because in the 1950s the food-processing industry learned how to turn raw spuds into frozen french fries, hash browns, tater tots, etc. And even as this tuberous evolution revised the American diet, the onset of its major corporations, with their packing and freezing plants, seriously changed the towns in the basin's irrigated districts. Othello figuratively gasped in relief as the onset of potato production picked up and reversed the slack created by the railroad's demise. Before long, Adams County's growers and processors were supplying half the nation's consumption of the beloved spud sticks.

Along with this industrial infusion into Adams's driest zone came the latest of the successive waves of immigrants who, through the decades, have shaped the county's ever-evolving future. The processors' factories needed wage laborers. The new, watered crops

needed field hands. And, with one notable exception, the people arriving to take on this work were—and are—from Mexico and Central America. Othello's commercial zone began to display restaurant and store signs in Spanish. By the 2,000 Census, the city itself was 64 percent Hispanic. Which—since Othello sports by far the largest-of-all municipal populations—in turn made the overall county demography 41 percent Latino heritage. That fact shows clearly and calmly in the slow infusion of Mexican-heritage children into the schools of Ritzville, Lind, and other wheat-country towns—places where their wage-working parents, still very much an ethnic minority, have found employment and the hope of community.

Unlike the earlier immigrant arrivals, who either homesteaded or rather inexpensively bought cropland, wage-earning Latinos encountered a dauntingly high economic threshold between them and full-scale farm ownership. But significant numbers have found other channels into Adams's entrepreneurial community. Aside from the retail and restaurant sectors, Latino names now show up in government and banking. Latinos have established trucking companies to bring supplies to growers and move harvested crops to storage or processing. In agriculture itself, potato growers such as Frank Martinez (see image 50) rank at the top of that profession. Like his cohorts, Frank leases landowners' watered "circles" for use in growing his crops. He has considerable capital investment in his planting, cultivating, and harvesting equipment and potato storage buildings, but not in the farmland itself.

Which is just the opposite of the other latest immigrants to Adams County: the communally farming Hutterites. The Germanic heritage of these unusual people reverberates with Adams's early arrivals, the protégés of Catherine the Great who had fled the Caucasus when their protection from military conscription was voided. Like the Mennonites among those first-comers, Hutterites are Anabaptists—believers that only adult persons can understand and accept the religious commitment that Baptism asserts. Their literal interpretation of the Bible instructs them to abjure private property ownership, to refuse military service (again, Thou shalt not kill), and to live cooperatively in colonies. After barely surviving the Catholic Church's attempts to obliterate them in Europe during the 1500s, the sect has quietly proliferated. Hutterites acquire land to farm until a colony grows so large that there is insufficient work for its productive members (usually at around 125 residents). Then, with funding assembled from communal treasuries, a spinoff colony is founded and buys land elsewhere, leaving to start the process anew. So it is that Hutterite colonization over hundreds of years has moved by long steps across Europe into Canada, and thence, decades along in the twentieth century, into Montana, Washington, and, most lately, Oregon.

Hutterites wear a form of what Anabaptists call plain dress: dark colored gingham and calico for women who sew garments for themselves, unadorned jeans and shirts for men, and all black worship clothes for both. Religious propriety requires head scarves for women, hats for men. Their worship services are conducted in German, which their children learn along with English. But these direct descendants of the Reformation reject the restrictive hand- and horse-powered methods of the quirky Amish, their better-known Anabaptist cousins. Instead, they employ the most modern and effective agricultural equipment and techniques. They do farm dryland, but their harvest also includes high-value potatoes as well as other irrigated crops in rotation.

So it is that in Adams County they have joined a species becoming endangered all over the west: growers who pump groundwater for their crops. Just as in California's Central Valley and in the vast spread of midwestern acreage above the Ogallala aquifer, the groundwater supplies under the Columbia Plateau are being exhausted: more is being pumped out than nature can replace. The water is being mined, and even what remains is sometimes worthless: one well in neighboring Lincoln County found water at 2,200 feet down, but it was uselessly acidic and smelly. Other deep drilling has brought up water as hot as 174 degrees (a home water heater usually runs at about 140 degrees).

Thus two immense ironies have settled onto the home ground here: first, in a locale where success was initially measured by the ability to bring harvest from under-watered soil, the onset of irrigation, has created an alternative mode that demands more from the land's liquid resources than the land can provide. And second, for growers depending on disappearing groundwater, salvation sits, actually and unreachably, within view—the truncated outreach of the Columbia Basin Irrigation Project. As originally planned, this great public works endeavor aimed to provide more canals and extend much more deeply into Adams County. As center-pivot irrigation came on so strongly, however, the plans for those additional canals were shelved. They're technically still on the list of possibilities, but it's clear they never will be built.

Irrigation advocates hope instead for a network of pipes and pumps that will bring along the Grand Coulee water originally intended for so much more of the drylands. That potential is still under study. But the earliest such relief could come is perhaps twenty years away. Meanwhile, might there be a time soon when it will be obvious that further pursuit of groundwater makes no sense? A respected local water analyst says, "We're at that point now."

There are signs pointing to possible future quandaries for dryland farmers, too. Increases in export output from Australia and China, for instance, are impinging on the market for Adams's premier crop

of soft white winter wheat (a staple for Asian noodle products, among other uses). Already some growers are hedging their harvest choices with a return to latter-day variants of the historically famous Turkey Red, a hard wheat used in pasta making. Others are investigating the developing market for fuel crops, although as of this writing the most prominent proposal for local entry into this business is a gimcrack deal that would ship by rail to Adams County immense quantities of midwestern corn for use in brewing ethanol. The only local inputs would be land, labor, and water, since wheat is not so good for the process. If only because of the county's shrinking water supply, this prospect seems increasingly unlikely.

Experiments, as yet unsuccessful, are under way for the development of a dryland variety of Canola, an oilseed plant useful in production of bio-diesel. But that remains a future hope. In the meantime, the one "plow-ready" crop that could be adapted to Adams's dry fields for ethanol harvest is switchgrass, a tall prairie plant with good alcohol yield. Will it happen? Can investors be attracted to build the necessary refineries? Will Adams's farmers take the plunge? At least one wheat-growing analyst sees gloom ahead, in the form of federal farm bills that accede to World Trade Organization demands for removal of commodity production incentives and subsidies, resulting in fewer farms (and more land taken out of production to satisfy "green" goals of conservation).

Adams County Development Analyst Roger Krug, himself a former potato farmer and buyer, disagrees. "I don't think it's going to be so much 'greener' in that way. Land's going to be in production. They're going to pay guys not to farm, but the bio-renewables are going to put them back in action. Certainly there will be always a Conservation Reserve Program because it's good for the environment, plus they're going to be selling carbon credits on that stuff to the oil companies, that kind of thing. But there's going to be as much land in production, it's just going to be different crops. Everybody agrees that there's not going to be as much wheat. But the land's going to be in production. It'll be in crop in renewable resources. We're going to be making our own fuel crops, and we can do it. You've got to think outside the parameters. Guys who think inside the box are going to be the first guys gone."

If the inside of that box holds the allure of traditional crops and subsidies, though, the outside opens to an unbridled world of speculative risk-taking in newly developing markets. Any significant shift from food to fuel crops in Adams County will require advances in both policy and science that may indeed be under way. If that shift does eventuate in a significant way, it will propel local growers into the mounting maelstrom of discontent as food prices rise while harvests go into refineries.

Whatever the outcome in that arena, farmers will

still be left to take on the onus of final dealings with chance. Krug's prescription for Adams County really applies to the whole world of agriculture. As another analyst put it, "You've got to be an optimist. If you're not an optimist, you won't be a farmer. You either go out of business or you'll have nightmares. Because it is the ultimate gamble: take all your money and put it out in the field, and hope that the rain comes at the right time, no damage from frost, no hail, no pests. The ultimate gamble."

There are plenty of growers in Adams County who will keep on making that gamble. And in the shrunken towns, already hard-pressed for resources, they're rolling the same dice. Nowhere is that more evident than in Lind, which was devastated by fire, snubbed by the interstate bypass, devoid of all but a few stores, and reduced to less than half of its peak population. Yet the town spirit here is insouciant, truly never-say-die. The sign out on high-speed U.S. 395 says, "Drop in! Mt. St. Helens did." The town's droll website asserts that Lind is "not without charm and history." A red satin-clad mannequin in an upstairs window of a downtown building recalls the salaciously named 1900s Rooster's Rest bordello.

And every year, Lind plays host to a raucous send-up of the very agronomy that created the town—the Combine Demolition Derby, held in June. Aged, retired harvesters, stripped of dangerous sharp projections and decorated cartoonishly with shark fins, pig snouts, mouse ears, and beaver teeth, roar into elephantine smash-mouth competition at the rodeo grounds (see image 74). It's an agrarian burlesque echoed around the world. Buñol, Spain, for instance, celebrates its tomato crop by mass, splattery throwing of the red ripeness. Ivrea, Italy, has the same messy combat with oranges. In Lind, the mechanical providers of the crop are made to pay. As one participant put it, "I don't think anyone, unless they've driven a combine, can understand the thrill of trashing one." They go at it with zest, and the last machine still rolling wins.

Which in itself is a metaphor for the town's dedication to staying alive. Carol Kelly, a former schoolteacher now instrumental in organizing the derby, puts it this way: "People here have the urge and need for Lind to survive. We're just not going to sit back and let this town blow down the road like a tumbleweed." As Lind goes—or rather, stays—so also go Adams County's other dry country towns. A culture that blends community need with resilience has created a foundation that at some level will sustain all of them, so long as the surrounding fields are producing crops.

In Othello, flourishing now with its infusion of latter-day immigrants and food-processing plants, the civic future is deeply dependent on water supply. But, in the meantime, Latino immigration that has centered there also has spread functionally to the grain growers' towns as well.

If Lionel could get high up enough to frame the whole county in his lens, he would capture a status quo that will be different even ten years from now, certainly twenty. The potentials are evident, but the certainties are not. Move the lens further up, and we'll see versions of the same dynamics at work throughout America's farming country. Hold the shot. Watch for the change.

Notes

1. This was particularly crucial for the Mennonites among them, practicing Anabaptists who hewed strongly to the Commandment "Thou shalt not kill," and therefore refused military service. In Adams County they founded the town of Menno, named for their doctrinal originator. The Mennonite Church still flourishes there.

2. Condensed from Clifford E. Trafzer and Richard D. Scheuerman, *Chief Joseph's Allies* (Newcastle CA: Sierra Oaks, 1992), pp. 7–8.

A Note from Lionel Delevingne and Steve Turner

Our friendship and parallel journalistic careers have taken us to every sector of North America. Whenever possible, we have organized assignments together, operating on the premise that each will present the subject with his craft, from his viewpoint—a mode of working that has yielded beneficially comprehensive outcomes.

This book emerges from that tradition—and from the fact that among all the locales we have visited for reportage, the drylands of central Washington most compellingly drew us both back for this longer, deeper exegesis. For Steve, the magnetism initially was simple: a complete and fascinating difference of climate and landscape from his green New England mountains. But that grew into admiration for the people who farm their living from this semi-arid place: Adams County.

And for Lionel, this place offered the perfect microcosm to expand and deepen his understanding of his adoptive country. "Photographers capture scenes," he notes. "We think we are in charge of what our camera ultimately reveals. And yet in Adams County, I was the one captured—by the extraordinary landscape, the determined families who make their livelihoods from it, and the friendliness and the cultural rituals of this off-the-beaten-path place. I am impressed by the staying power of the people I met—generations challenged but undaunted, still rooted in the land."

This work is a small tribute to remarkable Adams County, to the dreams of its people, and to the lasting friendship of its authors.

Drylands, a Rural American Saga

The Land

Adams County is a true fly-over zone: contrails (1) aloof in a winter sky show the way north to Spokane, west to Seattle. On the ground (2), snowfall that provides the major part of annual moisture in this relatively arid place highlights the sparse sketch of roads that link the county's few towns.

To the casual observer it can seem a place starkly designed for loneliness. But the land beneath the snow is both remarkable and inviting. In many places (3) the wind-sculpted surface of the deep, rich soils is enticingly feminine. Of course it was more so the landscape's fertile potential than its physical allure that drew farming settlers to these drylands. But the esthetically captivating nature of the new home ground was an added benefit.

Descendants have celebrated the efforts of the pioneers here who came in the late nineteenth and early twentieth centuries. Centennial town monuments highlight both the wagon trains and the railroads that brought early settlers.

Abandoned homesteads (8) record the failures of those for whom farming without sufficient precipitation proved unworkable. The cost of stock and equipment needed for effective harvest (12) was prohibitive when harvest yield was low. Even when more modern equipment became available, a farm budget could operate perilously close to the edge (11).

Nor was it only individual farms that failed. The cross-country Milwaukee Road simply quit in 1980, pulling up its rails, abandoning its stations, leaving behind only the megalithic supports that had transported the railway across Adams's coulees (13).

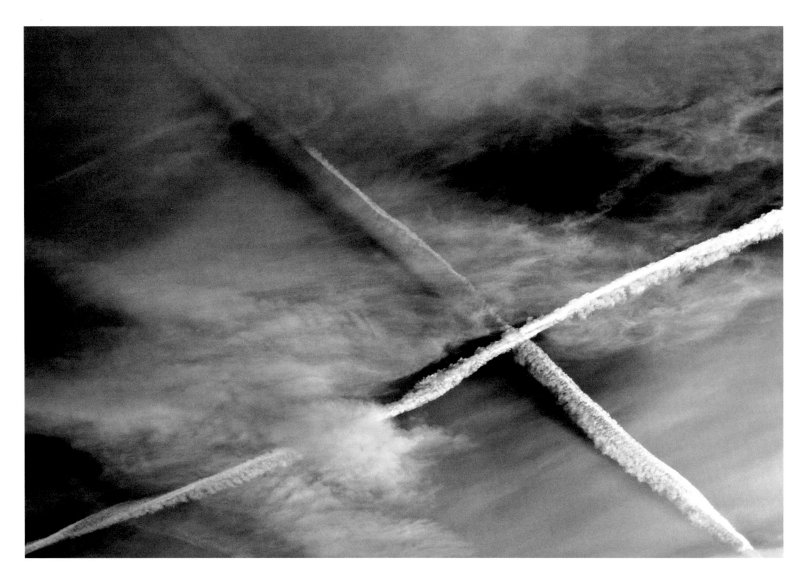

1. (*opposite*) Contrails in the winter sky above Adams County.

2. (*right*) Snowmelt yields a major part of Adams County's annual infusion of water. Snow cover on the ground emphasizes the sparseness of the sketch of Adams's major roads, but conceals also the warmth of the continuing community.

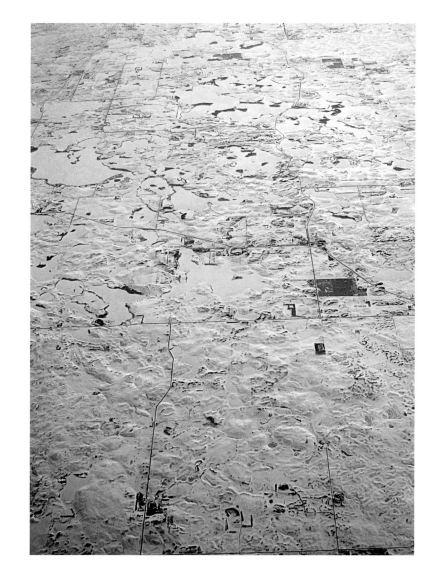

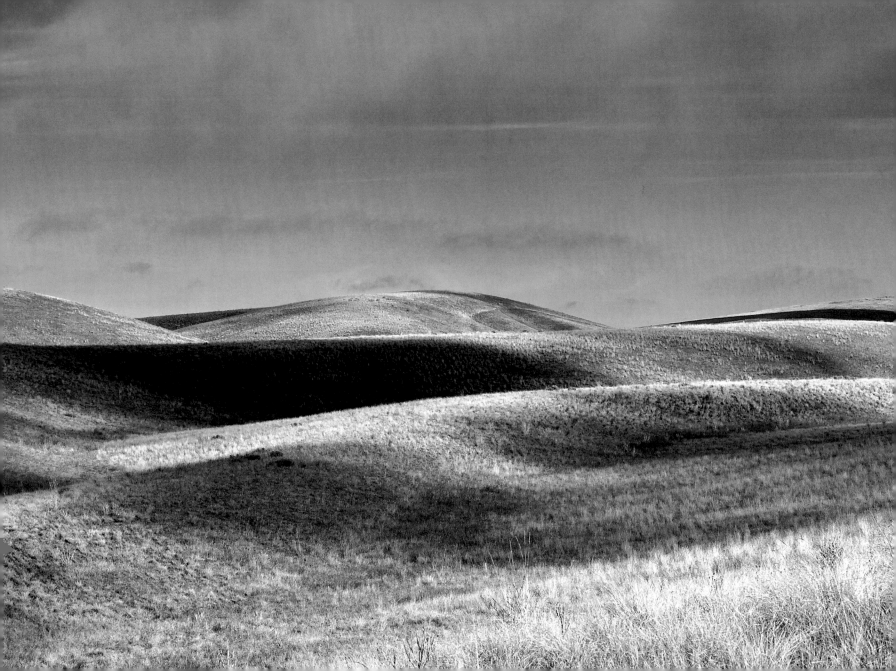

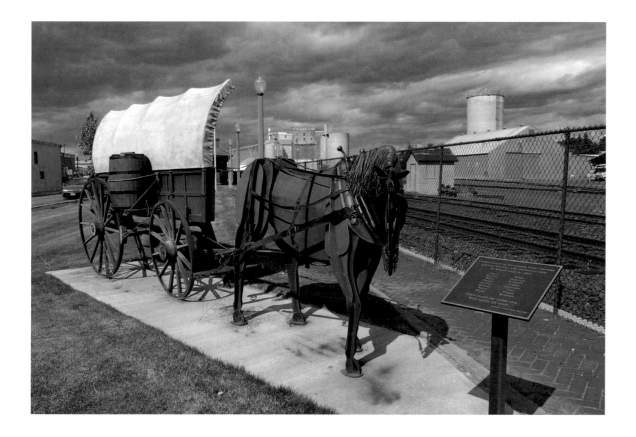

3. (*opposite*) The treeless landscape, formed by eons of windblown loess soils, can be strikingly voluptuous.

4. (*above*) Local towns celebrate the railroads and wagon trains that brought the county's earliest settlers. Here in Ritzville the display of historic vehicles and farm implements sits beside the still-extant railroad, consolidated from former separate entities into the Burlington Northern Santa Fe.

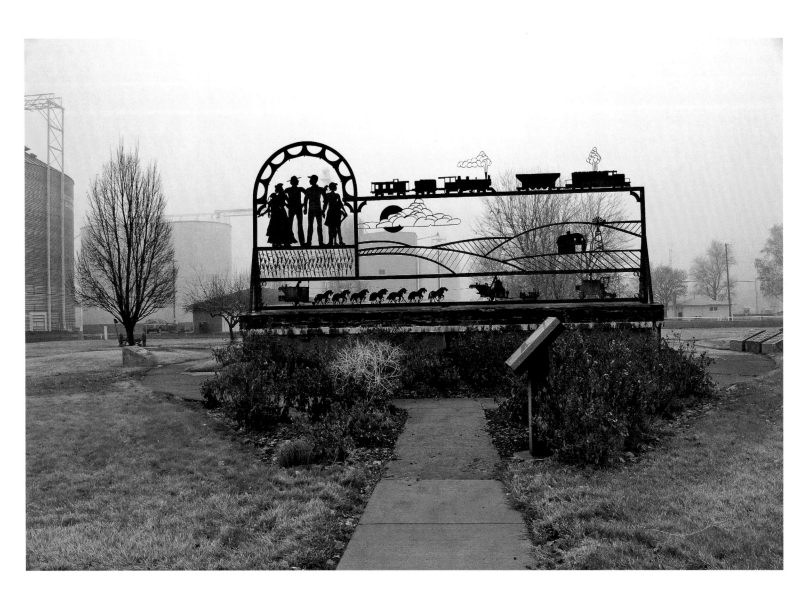

5. (*opposite*) The Lind centennial monument, erected in 1988, celebrates both the railroads and the evolution of wheat farming mechanization. The monument sits on land made vacant by fire that destroyed many commercial structures that have not been replaced.

6. (*Following page spread*) Where soil quality or topography rejects cultivation, the county's original covering of sagebrush and wild grasses still persists.

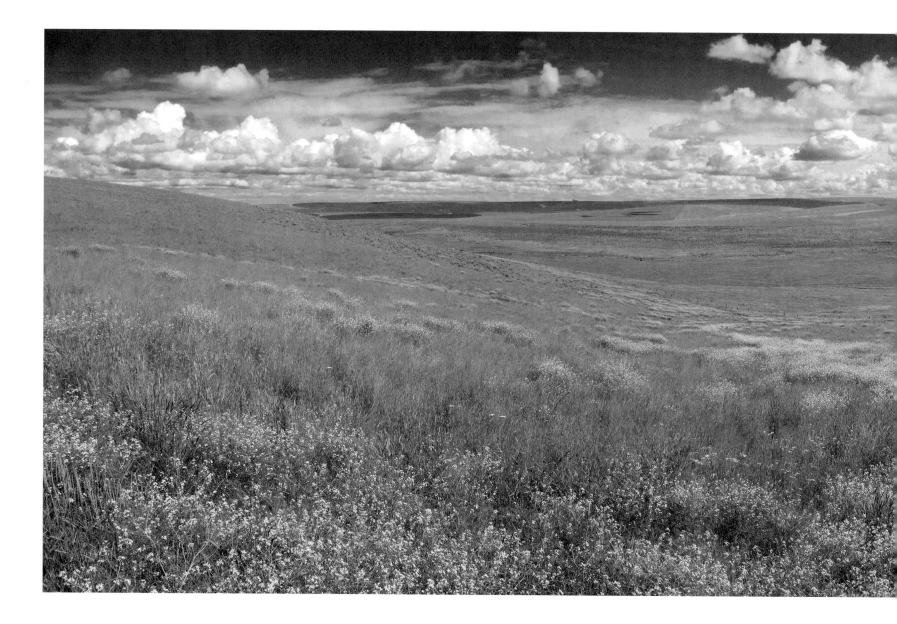

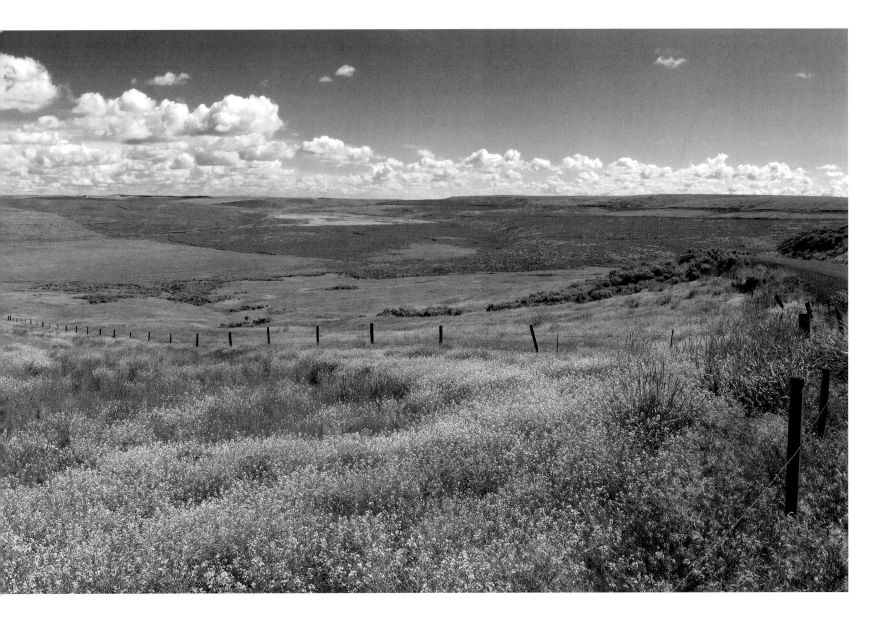

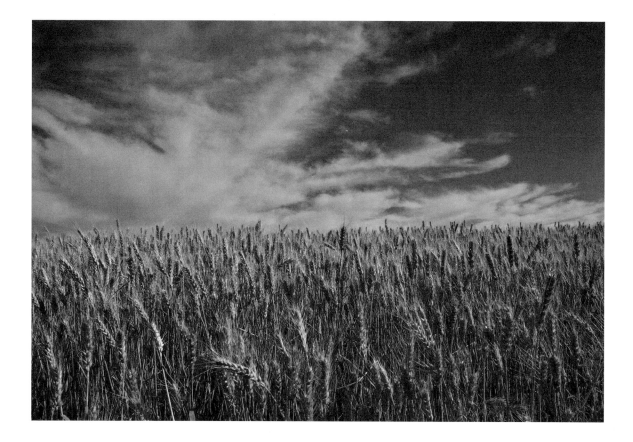

7. (*above*) If these impressive summer clouds produce rain, it will most likely fall as *virga*, evaporating before it reaches the ground.

8. (*opposite*) One of many relics of failed farming enterprises that dot the Adams landscape.

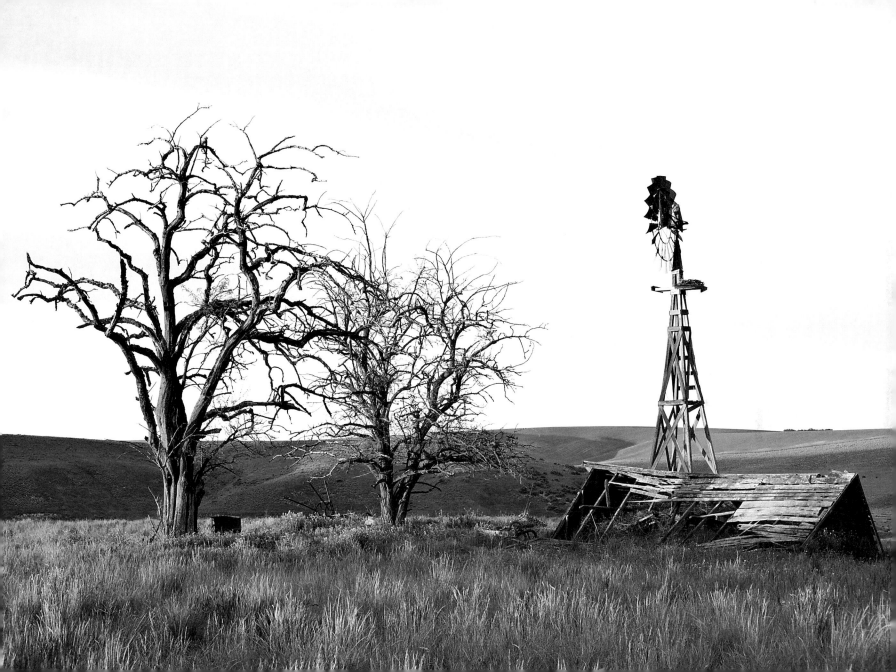

9. A look backward from today's streamlined technology to the time when the leverage of mechanical control often was human-powered.

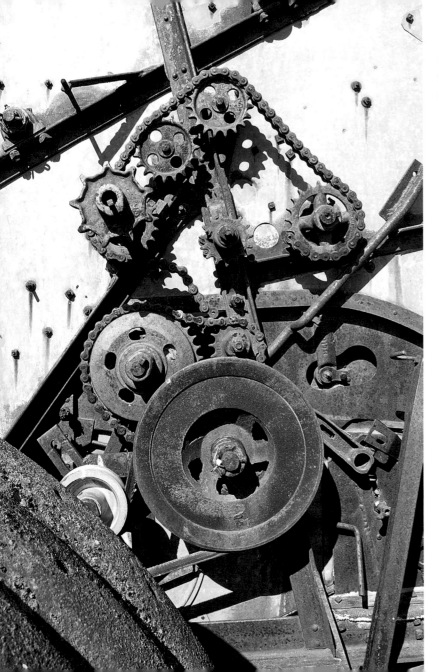

10. An abandoned combine displays the complexity of early agricultural mechanization.

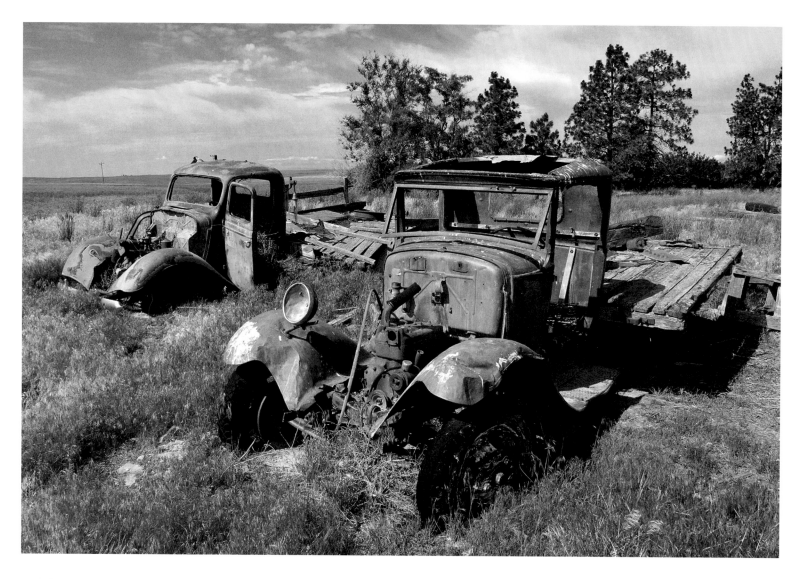

11. (*opposite*) Trucks became the workhorses of mechanized agriculture. Owners of the farmstead in the background simply put these aged models to rest when their useful days were done.

12. (*right*) Abandoned and upended water storage tanks provoke curiosity along Cunningham Road in the county's southern reach.

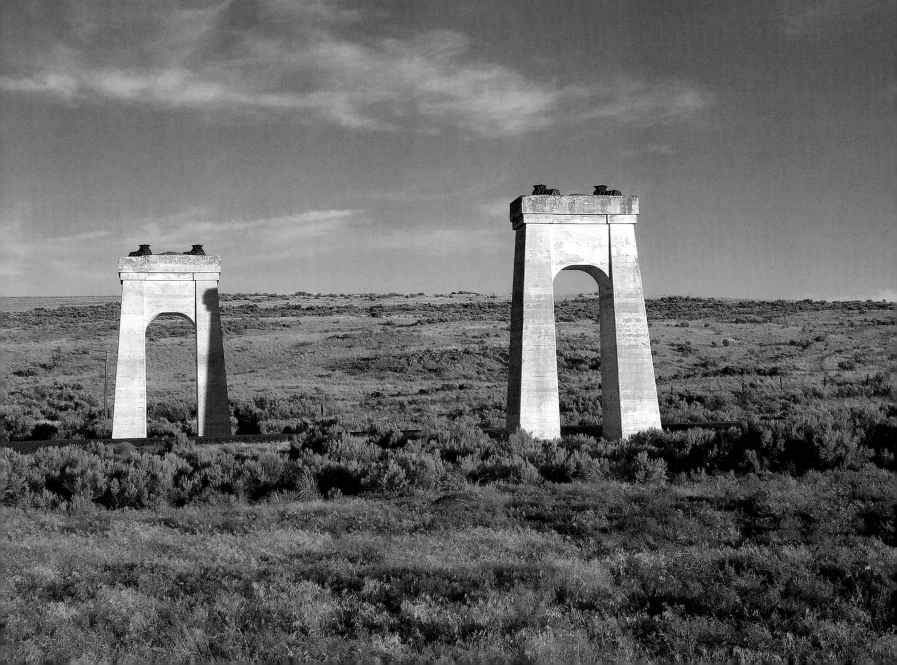

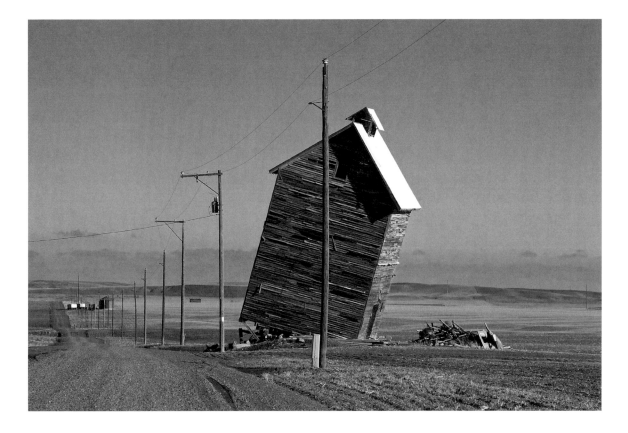

13. (*opposite*) These Stonehenge-like megalithic monuments once supported the Chicago, Milwaukee, and St. Paul Railroad—the Milwaukee Road—in its transit across the deep Lind Coulee. Imagine water flowing as high as their tops and as wide as the photograph guides the eye—this was the scope of the prehistoric Bretz floods.

14. (*above*) The past, fighting its demise.

15. Almost like a dead person's belongings, the sadness of a family's extinguished vitality.

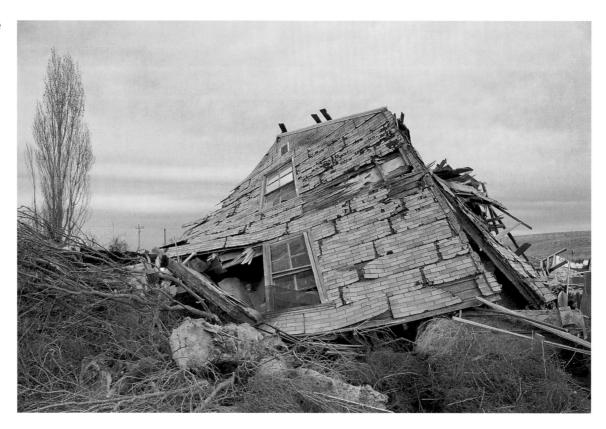

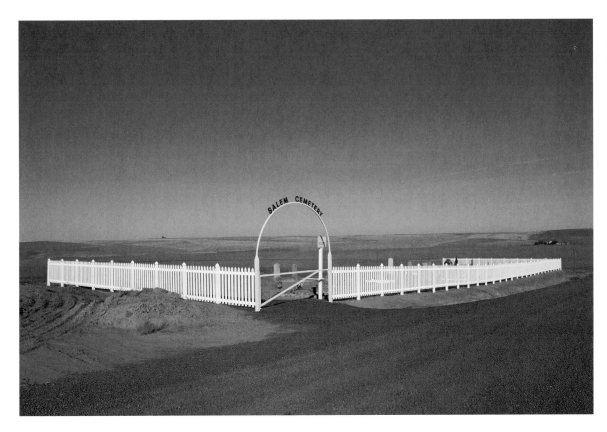

16. In a bright defense against the empty scope all around, the living defend their ancestral dead at the Salem burial ground.

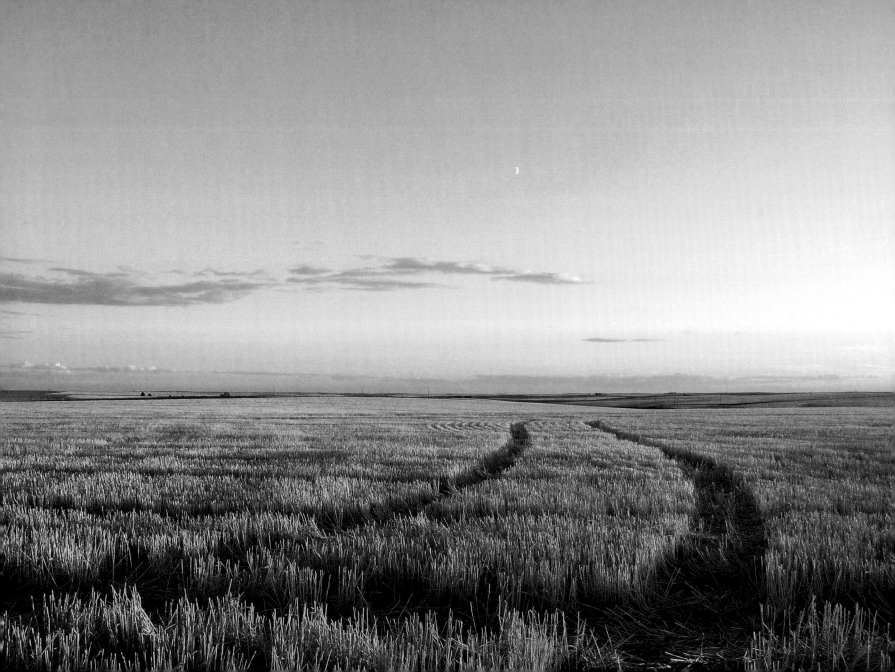

17. (*opposite*) There is an existential quality to harvest here: when the crop is in, it is as though that is an end. In reality, it is a beginning: the same combine that left its tracks when leaving the field will be back in two years to harvest again.

18. (*right*) High hopes, but unknown prospects.

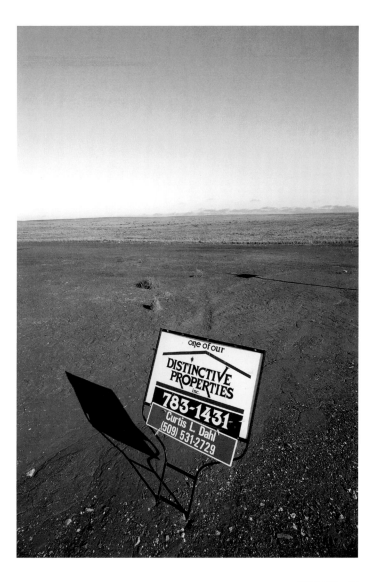

The Farms

The land has its own imperatives: in some places variability of the soils or the mixture of their emplacement tests the skill of farmers to find the line between useful fertility and where good crop won't grow (19). The sky can be dishearteningly fickle. Clouds that mass beautifully in summer can dash hopes in several ways. They may cruelly generate virga—precipitation that evaporates before hitting the ground—or they may yield hail and fierce winds that flatten crops. Or they may fork out lightning that can start wide-spreading fires on the ground. But seldom do they release the needed beneficial rain.

From the beginning of agriculture here, those who've sought to make a farming livelihood have been challenged by the scope of the difficulties they faced. Those who have succeeded share an understandable if quiet pride as well as a sociability of shared enterprise, whether it be crop or cattle that's produced. Arguably, the land, in its visceral attractions, has been made more beautiful—or at least more interesting—by

the work of growers who urge the soils toward maximum productivity. Plowing and cultivating carves supple, eye-catching, wide-spreading inscriptions in the ground. As farmer Roger Smart puts it, in college he was a student and practitioner of fine arts, but his post-graduate artistry has evolved: "I'm into stripes now," he says, referring to his equipment's markings on the soil. "Big stripes, and patterns."

Annie, Roger's wife and partner, celebrates his tendency to plow curves and circles where going straight ahead would be the normal thing to do. Known also as Blowtorch Annie, she uses their welding equipment to produce widely renowned metal sculptures. "We're about the most laid back farmers around," says Annie. "You've got to have some fun in life."

Or call it simply a variety of joy. Success here, even if measured close to the margin, brings the satisfactions both of elemental competence and of producing food—that most necessary of necessities—for sustenance of limitless numbers elsewhere.

19. Careful but artistic cultivation around a draw, where runoff accumulates and soils are leached.

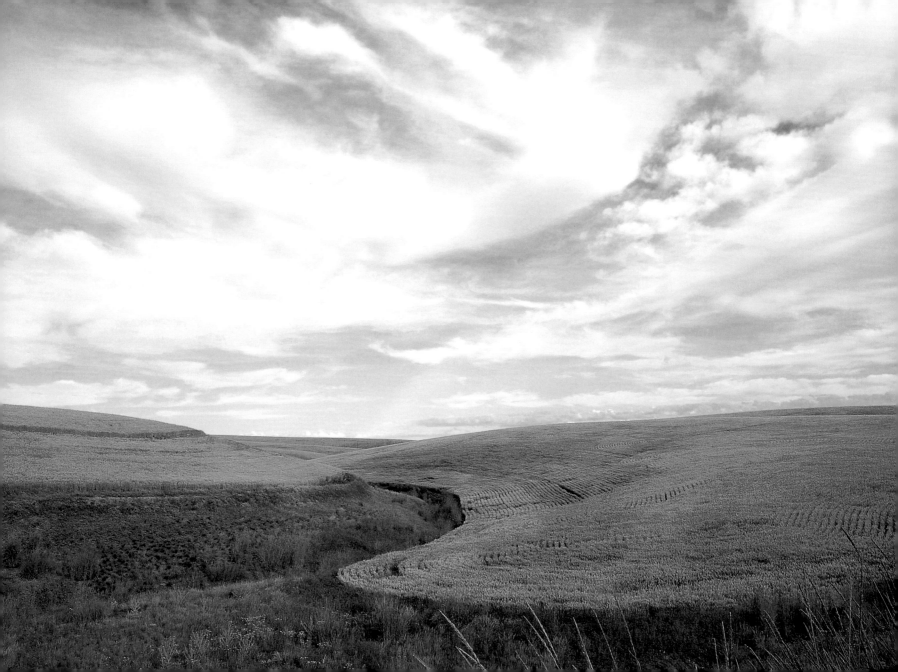

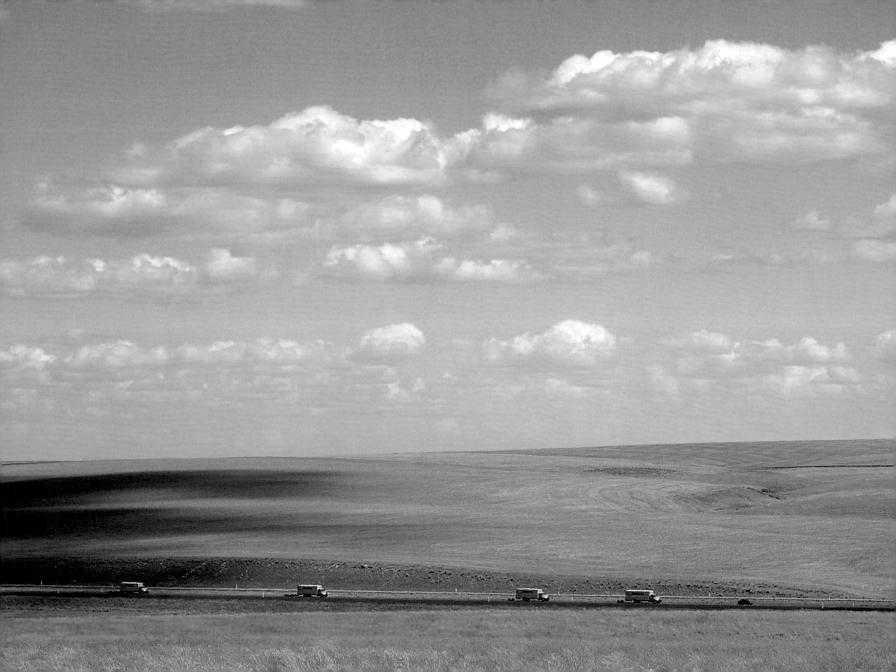

20. (*opposite*) Route 395 runs along the bottom of the vastly wide and deep Paha Coulee.

21. (*right*) A state road cuts the line between this year's crop and fields fallowed after last year's harvest.

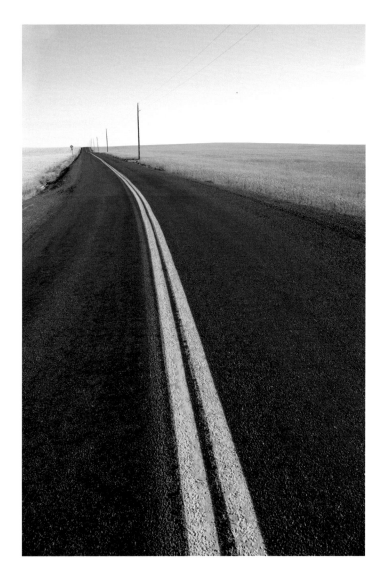

22. (*right*) A gravel county road explores the enticing landscape.

23. (*opposite*) Deer thrive here, as do pheasant. Even the occasional moose shows up. In earlier days, crop-damaging rabbits were so prolific that farmers went on group hunts to keep them in check.

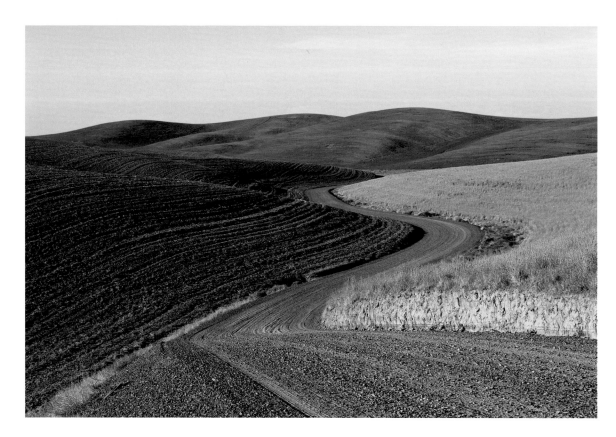

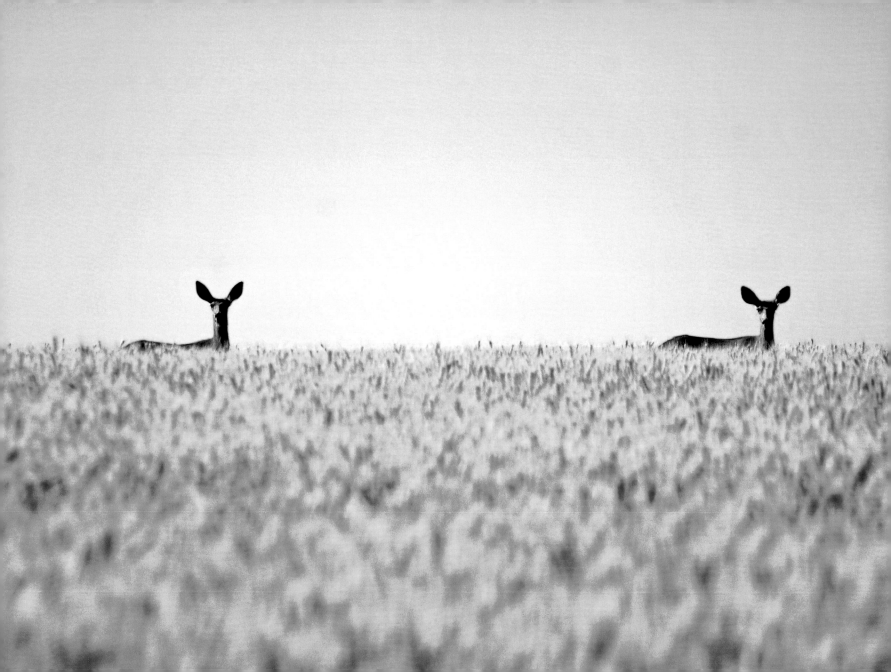

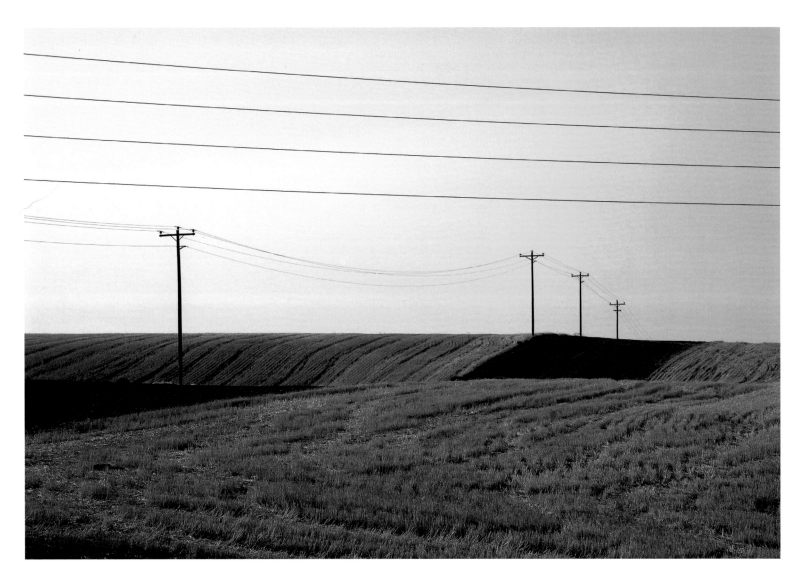

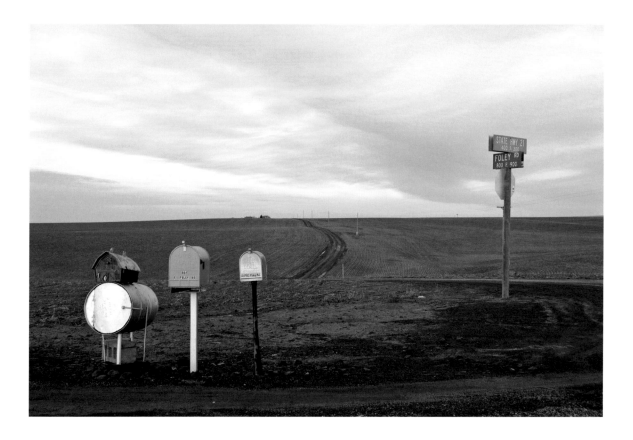

24. (*opposite*) Utility service lines often are the only evidence of distant farmsteads.

25. (*above*) The few paved state routes intersect every mile with the county's east-west and north-south grid of gravel roads, which together define the basic land measurement connecting the remaining farmsteads.

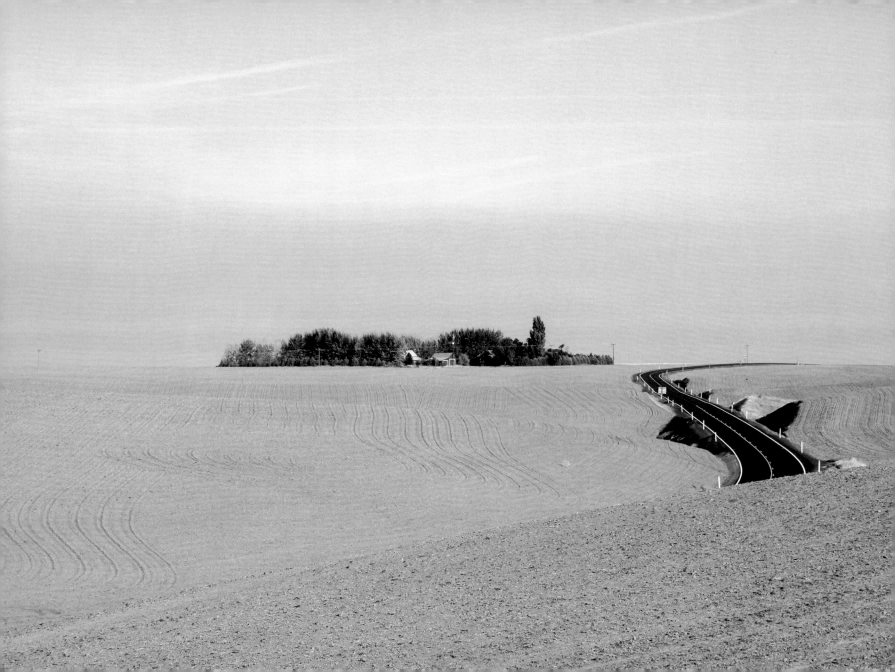

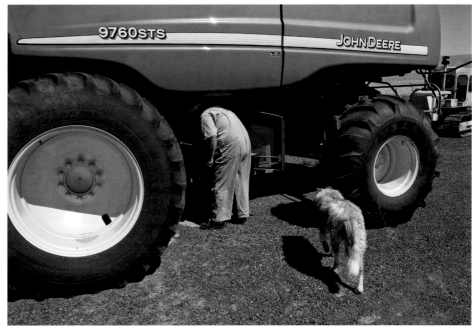

26. (*opposite*) A flourishing farmstead, visible for miles in its thick windbreak of trees, rides the sea of wheat. Again, the road divides this year's wheat crop, recently harvested, from last year's fallow.

27. (*above*) Farmers Grant and Nancy Miller beside one of their fields.

28. (*right*) Grant Miller checks out a new combine.

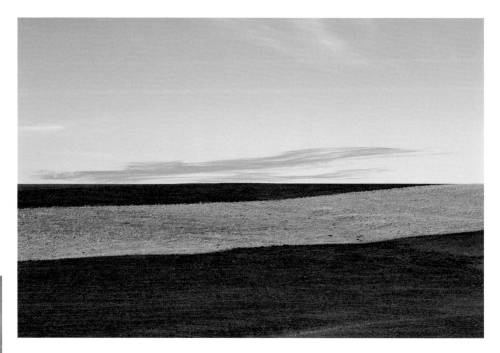

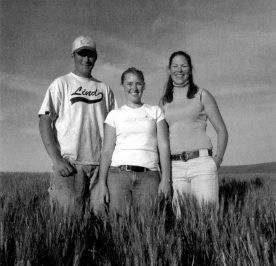

29. (*left*) The Miller children: Matt, Karlee, and Amy.

30. (*above*) Plowman's progress.

31. (*opposite*) Traditional native grasses are planted to hold the soil in the Conservation Reserve Program.

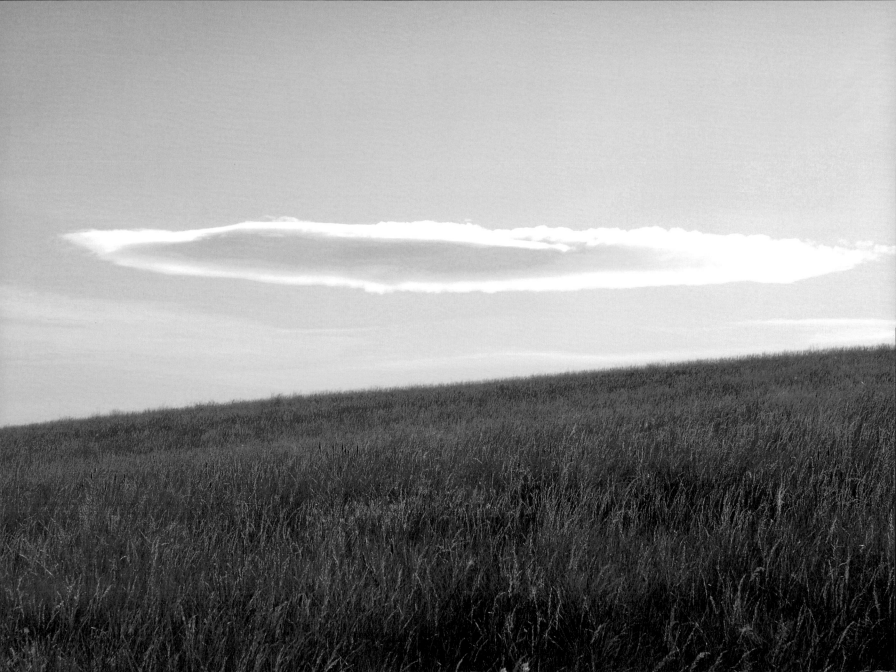

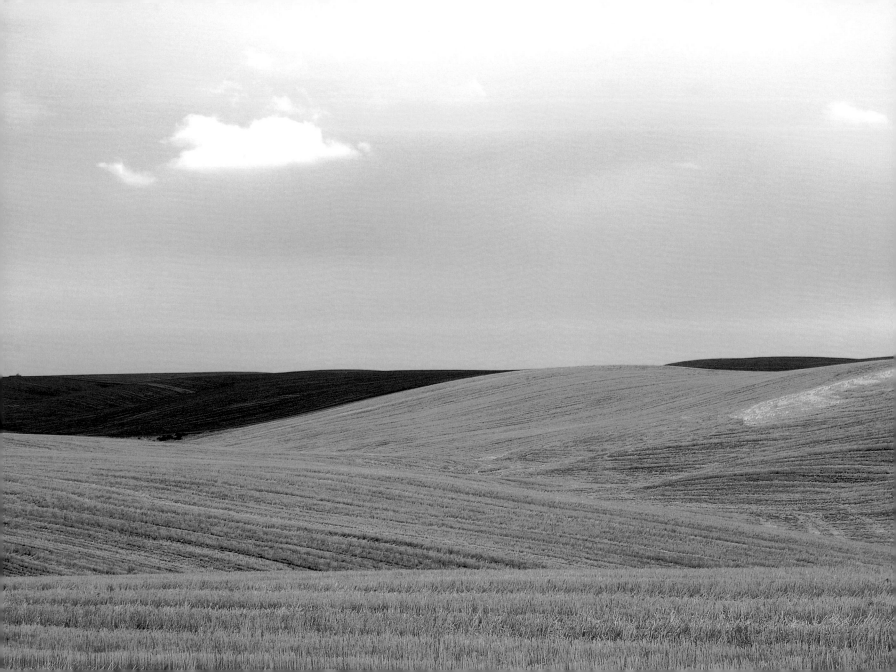

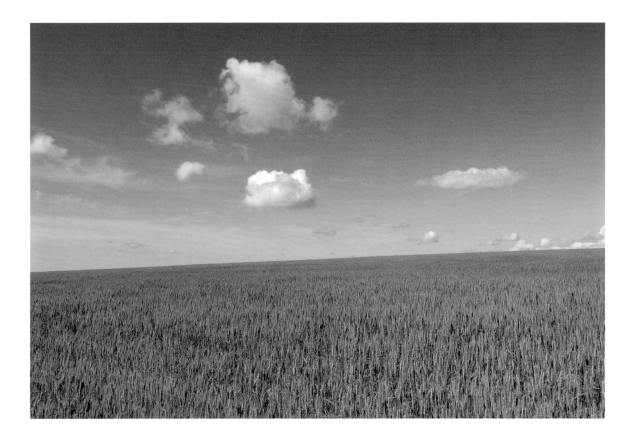

32. (*opposite*) Close together but a year apart:
previous crop's stubble, new crop's green.

33. (*above*) Young wheat in abundance.

34. (*above*) Wheat midway through ripening toward harvest.

35. (*opposite*) An irrigation rig in the west end of the county.

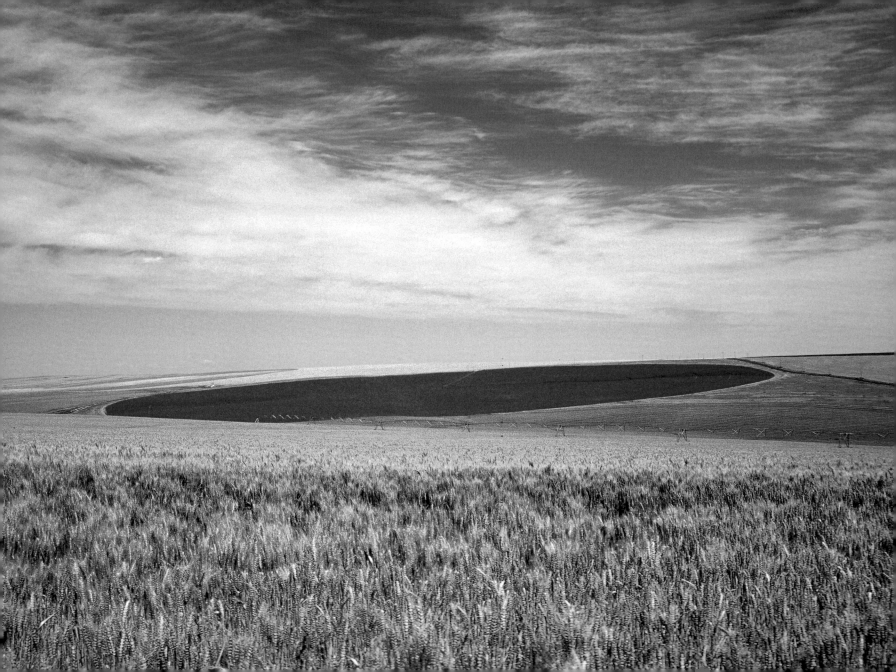

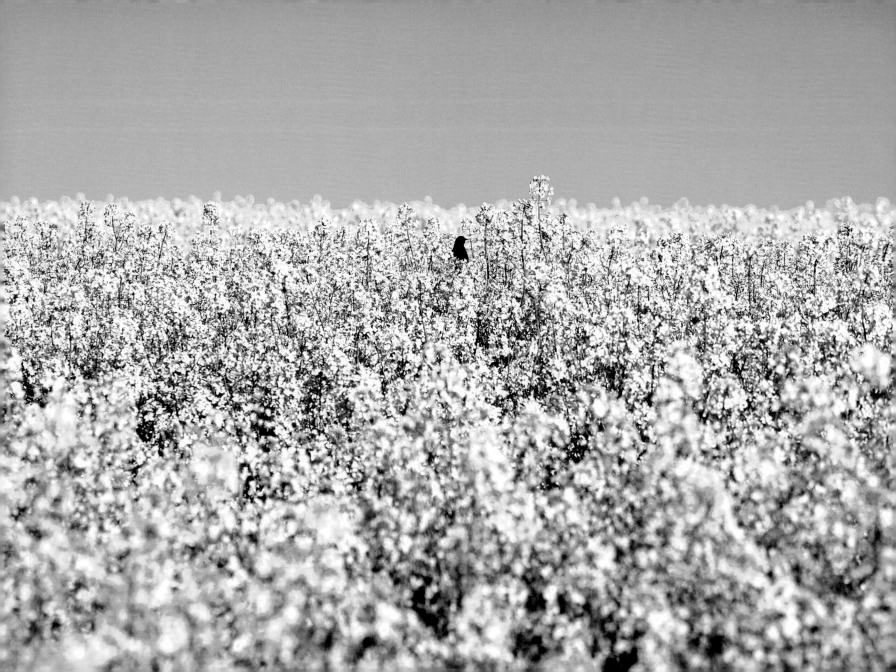

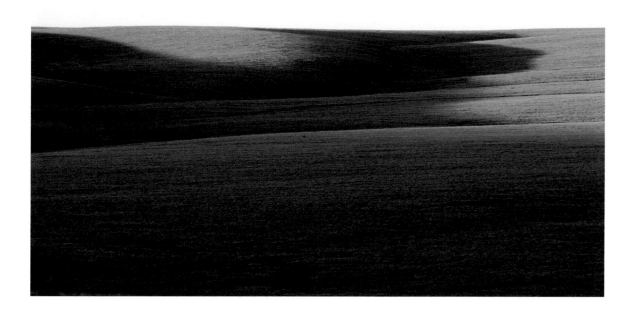

36. (*opposite*) Irrigated canola south of Ritzville.
Ongoing research aims to develop a dryland version of
this valuable oil seed crop, but with no luck as yet.

37. (*above*) Dusk on the land.

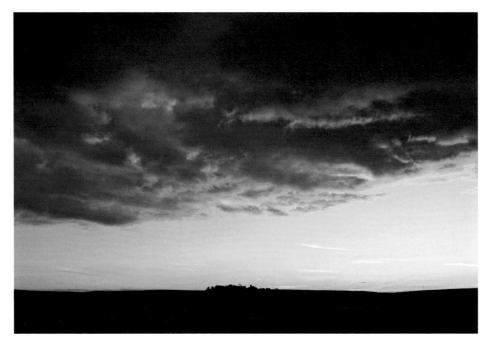

38. (*left*) The Smart family farm.

39. (*below*) Annie, Roger, and Sophie Smart, plus Niner, at their farmstead.

40. (*opposite*) Farmers have to be mechanics, too. Roger Smart works on his tractor.

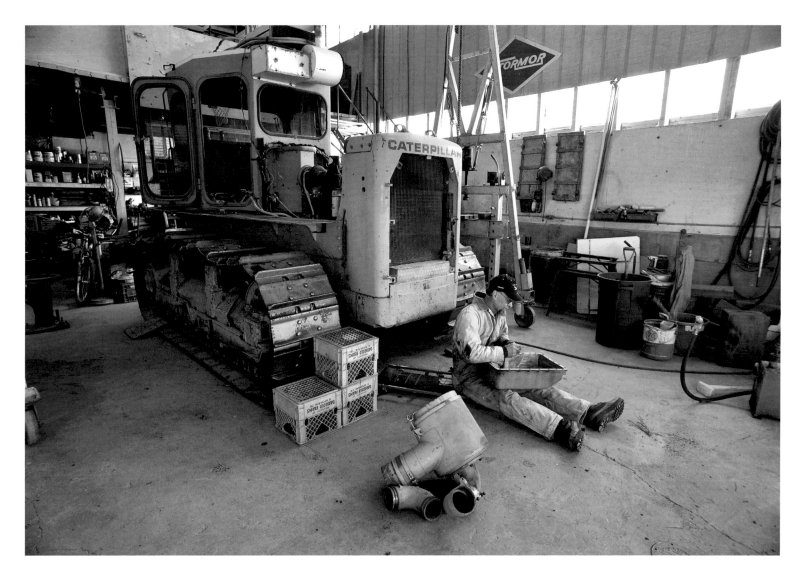

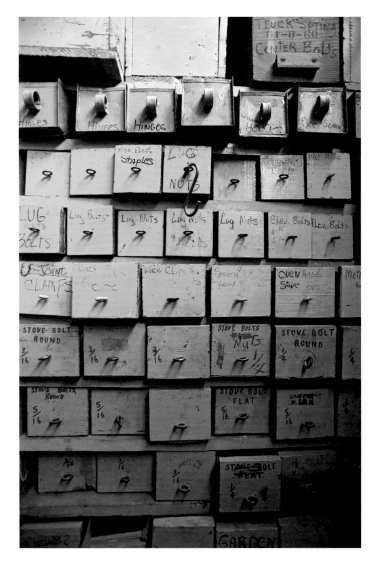

41. The "fixit file" in the Smart farm's workshop.

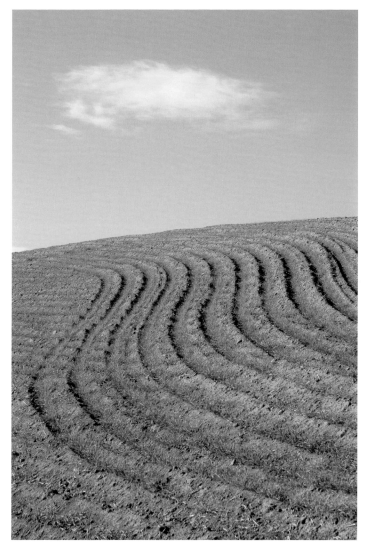

42. Artwork in the field.

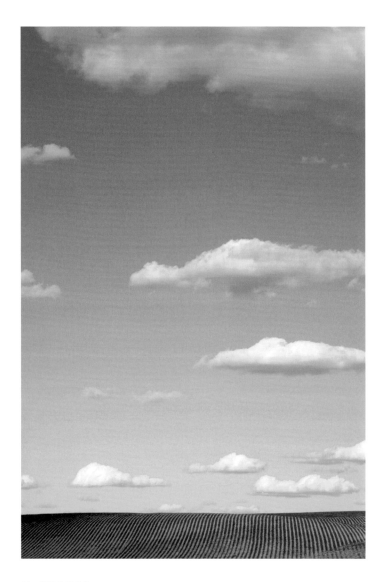

43. (*opposite*) Vertical serenity. On the relatively few windless days, the sky can be clear of dust.

44. (*right*) The imprint of harvest.

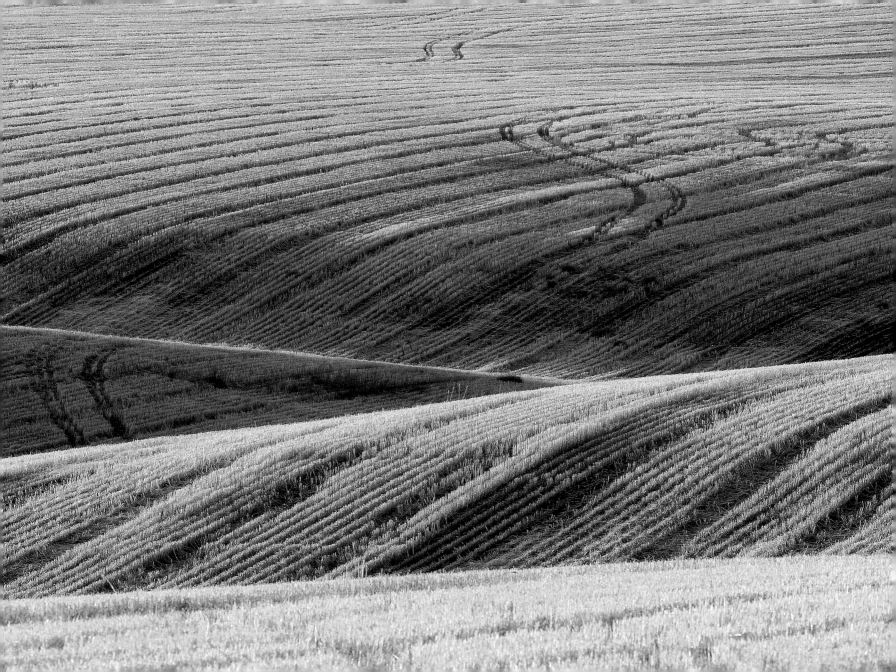

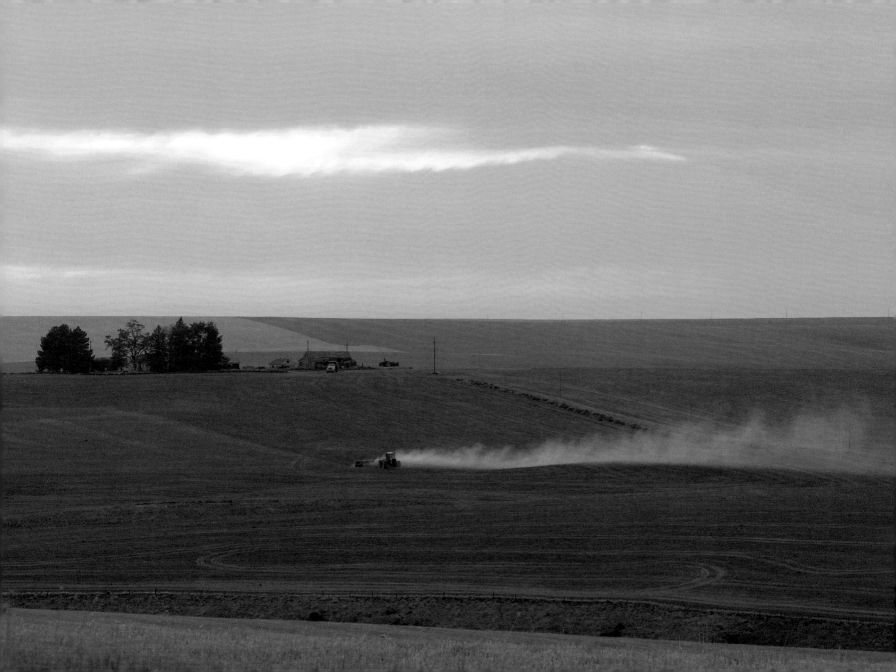

45. (*opposite*) The workday runs late.

46. (*right*) Cattle rancher Jake Harder.

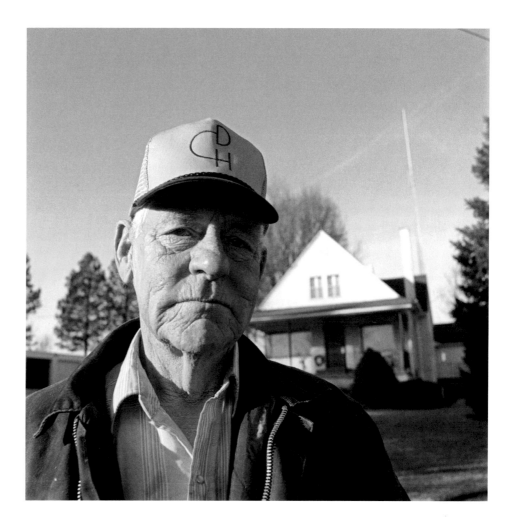

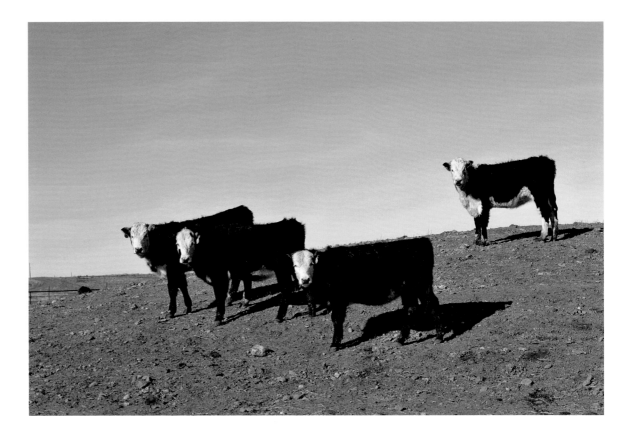

47. (*above*) Young steers from the herd on the Harder range.

48. (*opposite*) Another successful farmstead rides the big surround of its crop fields.

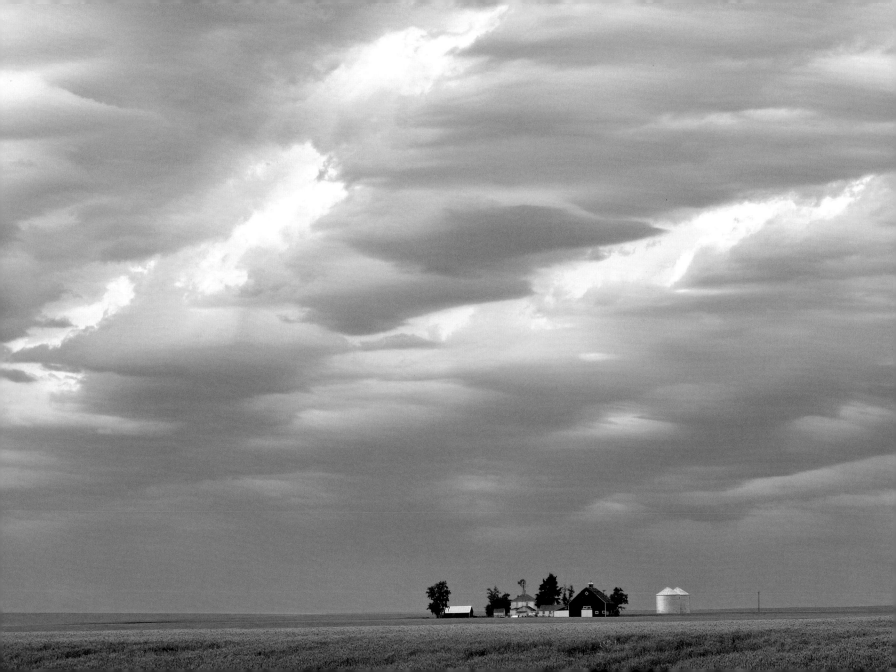

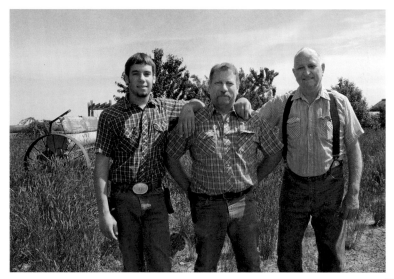

49. (*left*) Three generations of Hennings men—Hans, Curtis, and Willard—are Ralston area ranchers.

50. (*below*) The family and crew of potato grower Frank Martinez.

51. (*opposite*) Hutterite workers in a Warden Colony potato storage shed.

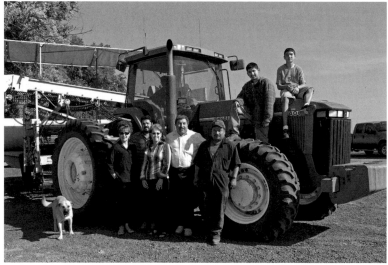

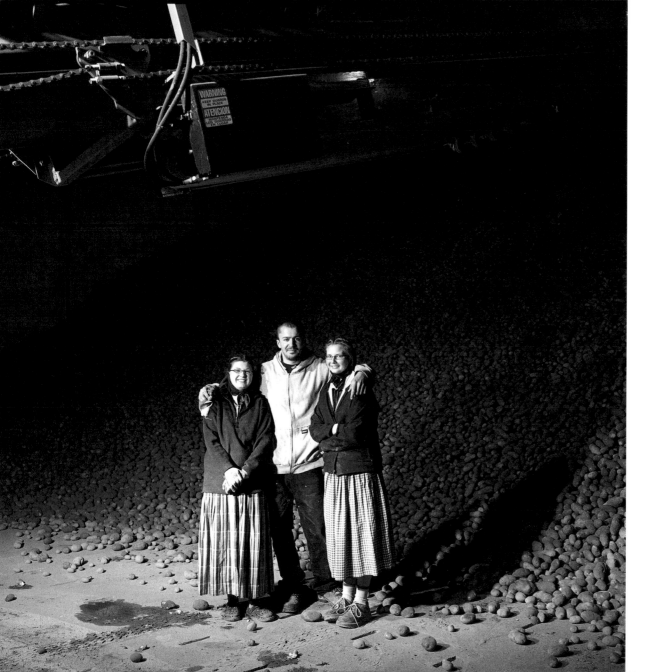

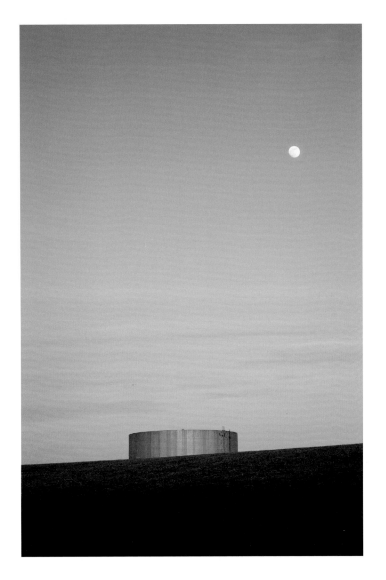

52. (*left*) Water storage up-slope from Ritzville.

53. (*opposite*) The railroad brings in goods of the world from Pacific coastal ports, and takes away cargoes of grain. A crossing near Cunningham.

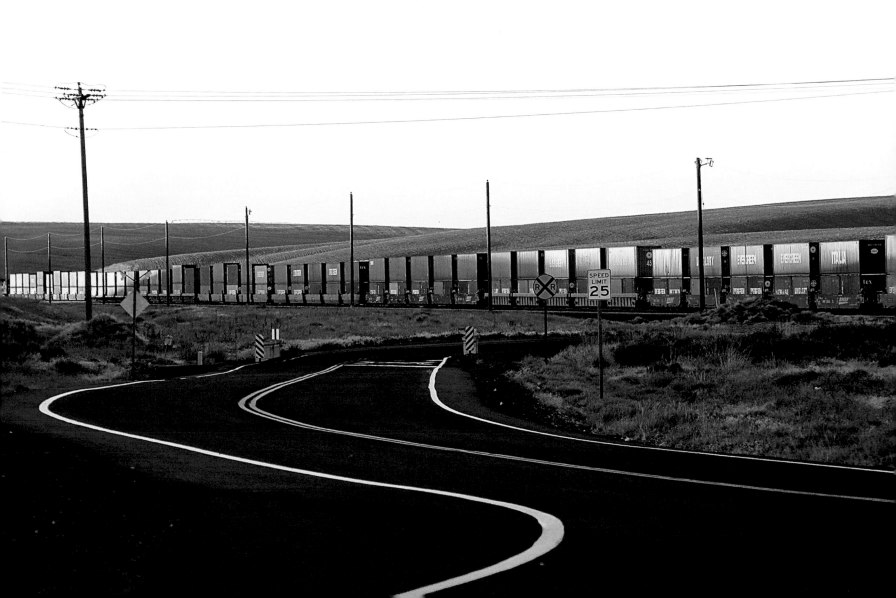

54. Winter closes down near
the tiny town of Tokio.

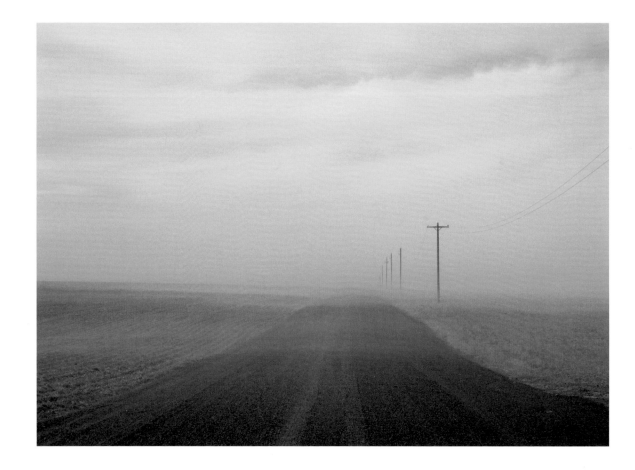

The Towns

The impact of shrinking farm population is clear in the wheatland towns—Lind, Ritzville, Washtucna. Commercial buildings boarded up, parking spaces empty. Lind's movie theater is long closed, leaving Ritzville's Ritz Cinema as one of only two in the county; the other is miles away in Othello. The Ritz runs films three nights a week, one showing per night only. Ritzville is also home to the county's only barber west of Othello, and sole mortician.

A more vibrant past is evidenced by main street relicts. Yet, reduced as they may be, the towns still function dynamically as centering points for the farming population spread around them. Here are the schools, their sports teams still bolstered by civic pride. Here are the churches, and the civic ceremonies that celebrate the people's cohesion as well as their integration in the American ethos. Street-side decorations at Christmas, flags for national holidays, Fourth of July parades with competing floats and convertibles carrying town festival queens and princesses. Municipal

birthday celebrations featuring rodeo competition, auto collision races, and, most impressive of all, Lind's annual Combine Demolition Derby. Adams County's official fair is held in Othello, but the annual Wheatlands Community Fair in Ritzville offers similar display: flowers and baked goods along with varieties of grain seeking best in show; 4-H club youth competitions in raising farm creatures of all sizes: chickens and ducks, pigs, goats and sheep, cattle and horses.

The spirit of this place stays alive in youthful replications of the evolving agriculture that has defined it. Despite the changes that farming technology has imposed, the memories of a storied past still have impressive cultural weight. Shrinkage already has seen the disappearance of a goodly number of former post office towns, now known only by the names of roads that once went there. The grinding forces of technology, marketing, and finance will continue to winnow the roll of survivors still out on the farm ground.

But there will be an endpoint to that depletion.

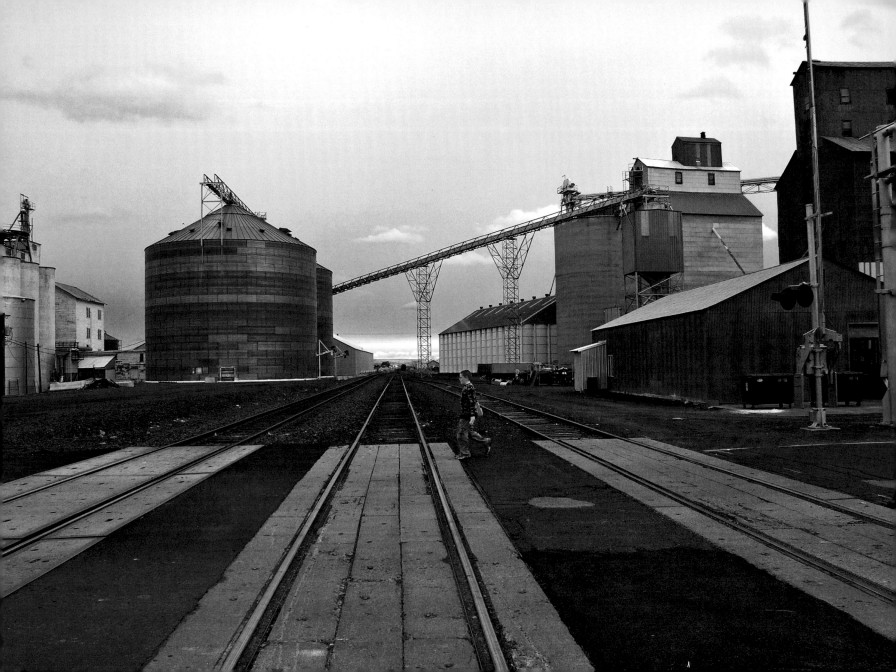

Corporate farming elsewhere has separated farmers from ownership of their lands. Not here. The particularities of the soils and the climate will always require knowledgeable farmers on their own acreage in Adams County in order to generate salable crops. The acreages may have to be large and the farmers may have to have family corporations, but here in Adams County an evolved form of family farming will continue to dominate.

And will continue to bring sustenance to us all. Because this is fertile ground, and the world needs the food that can be and will be produced here, by the people who know how to do it.

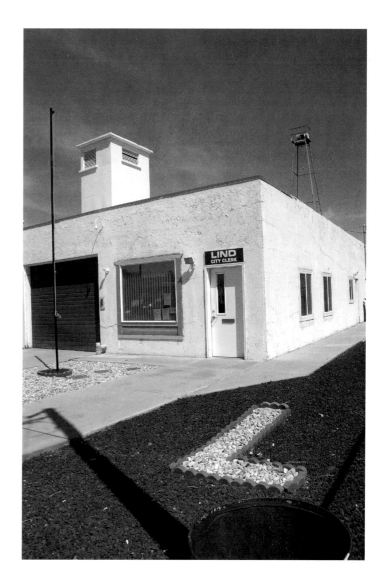

55. (*opposite*) The real business end of Ritzville: the Burlington Northern Sante Fe tracks serving the grain storage elevators of the Ritzville Trading Company.

56. (*right*) Lind City Hall.

57. West Main Avenue, Ritzville.

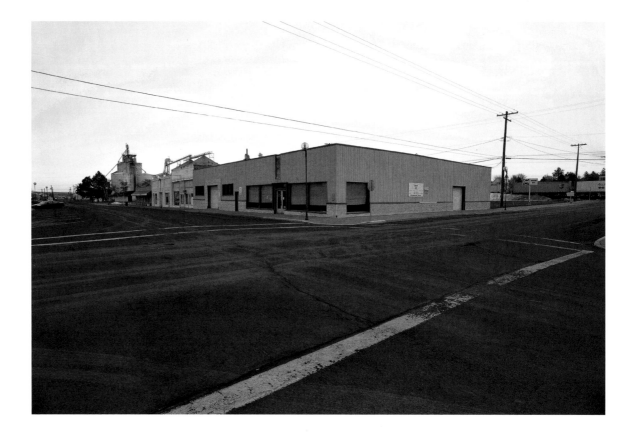

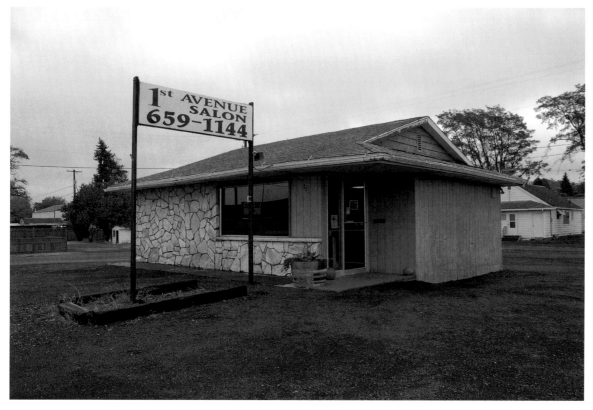

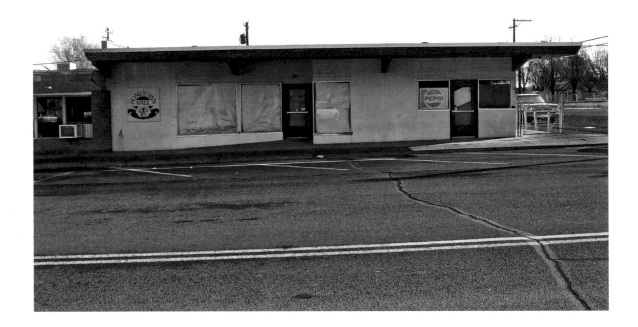

59. (*above*) Warden commercial district.

60. (*opposite*) L Street, Lind.

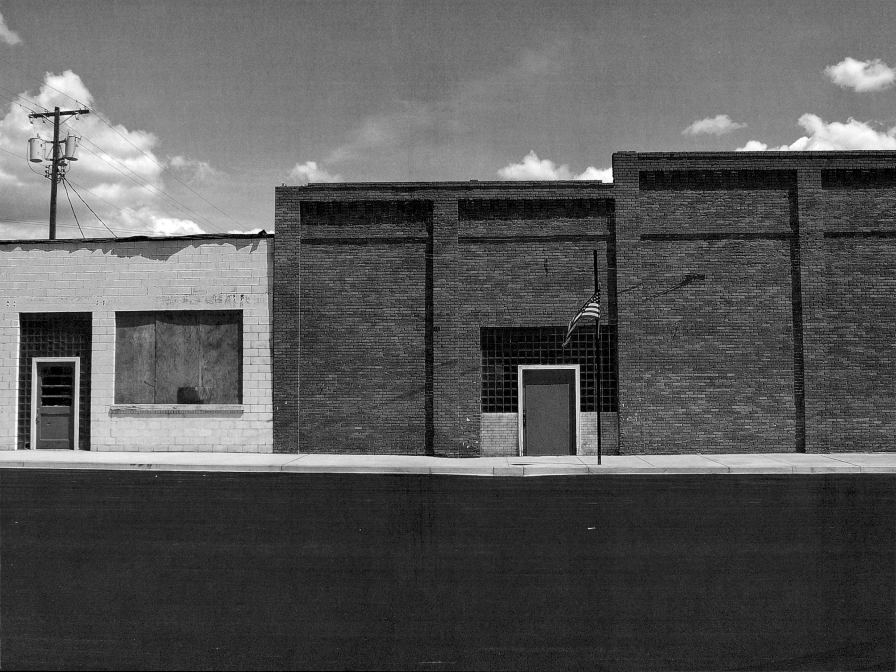

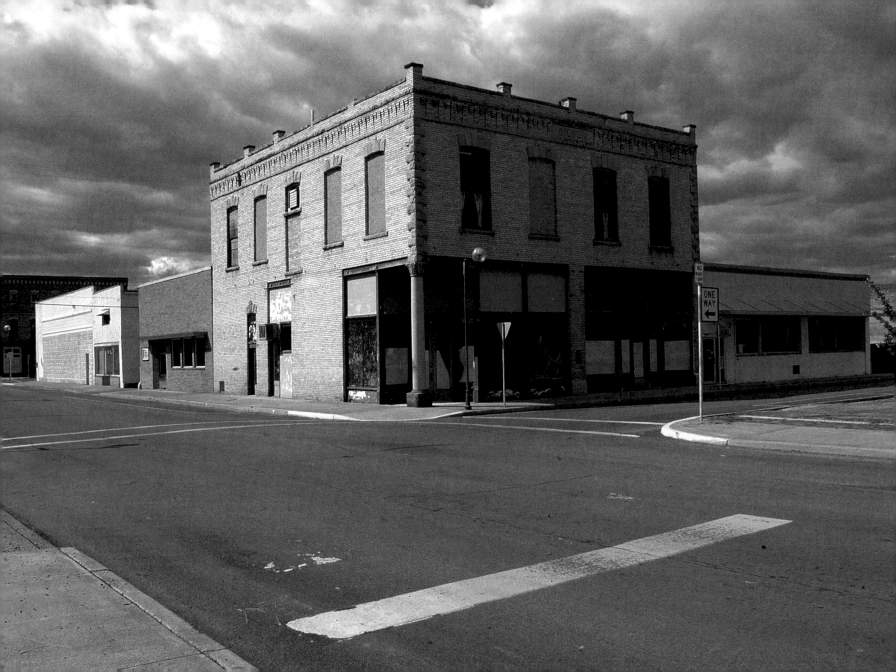

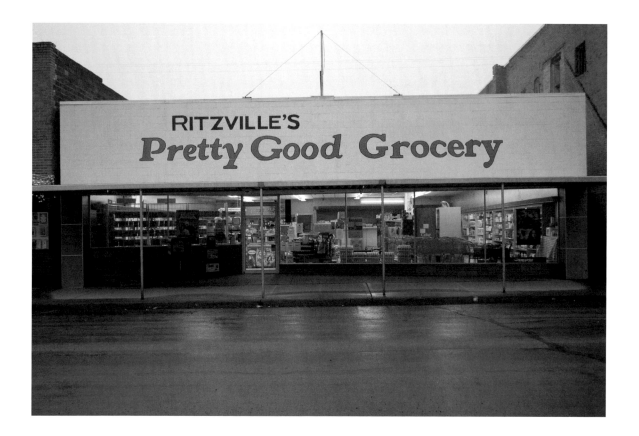

61. (*opposite*) East Railroad Avenue, Ritzville.

62. (*above*) One of Ritzville's two grocery stores.

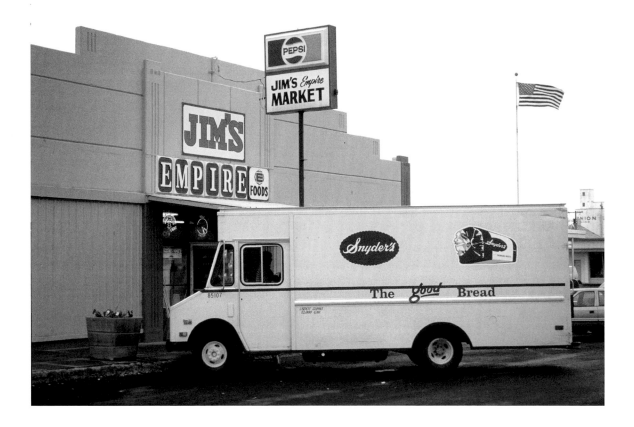

63. (*above*) Jim's Market, Lind.

64. (*opposite*) The Ritz Theater, Ritzville: one show each on three days a week. The only movie house east of Othello, serving three-fourths of the county.

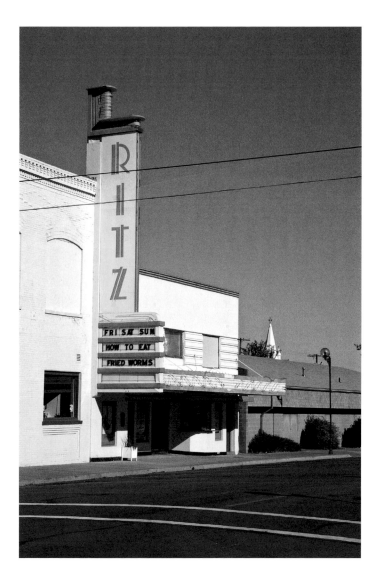

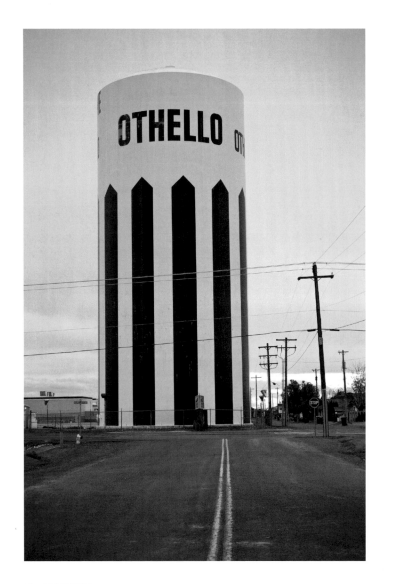

65. (*left*) Othello's water tower, the city's principal landmark.

66. (*opposite*) Othello's celebratory remembrance of the days half a century back when it was the hometown for a nearby U.S. Air Force radar installation.

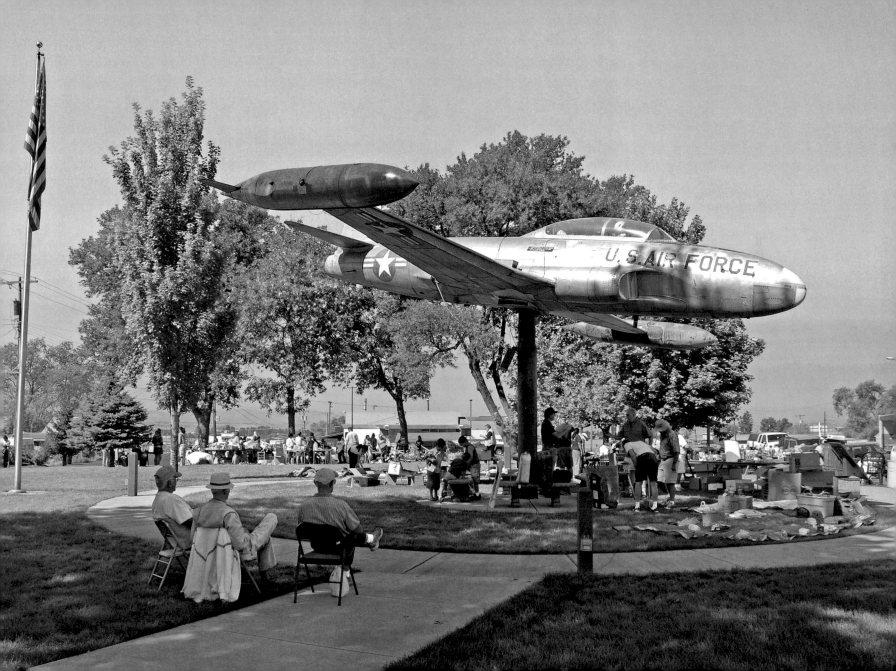

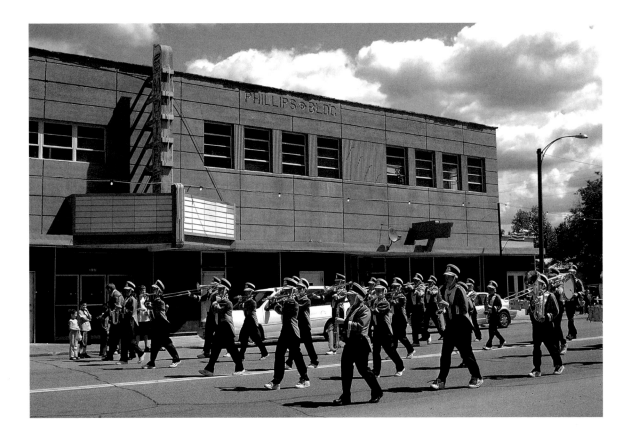

67. (*above*) A high school band in Lind's Derby Days' Grand Parade marches past the Phillips block, once the preeminent business address in town. The movie theater has long since closed.

68. (*opposite*) Lind's Grand Parade draws some unusual entries.

69. (*left*) The Combine Demolition Derby: a family event.

70. (*opposite*) Vintage Buick, Lind's Grand Parade.

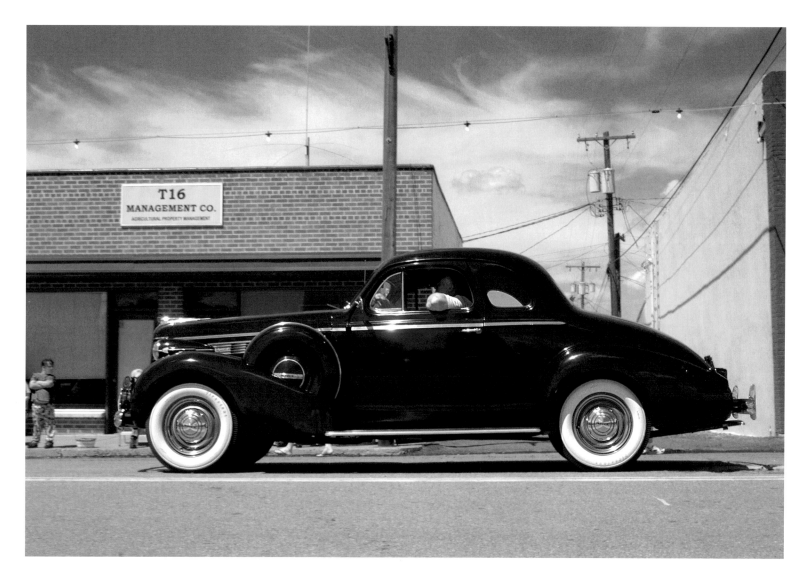

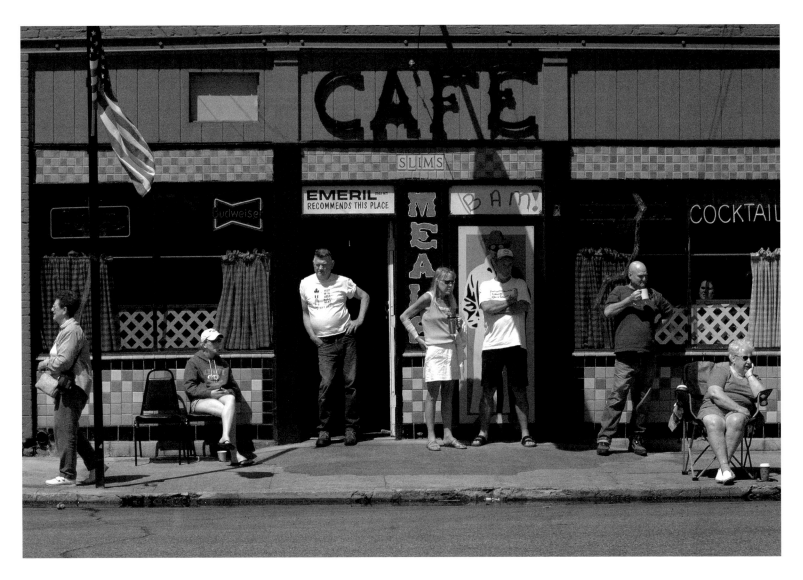

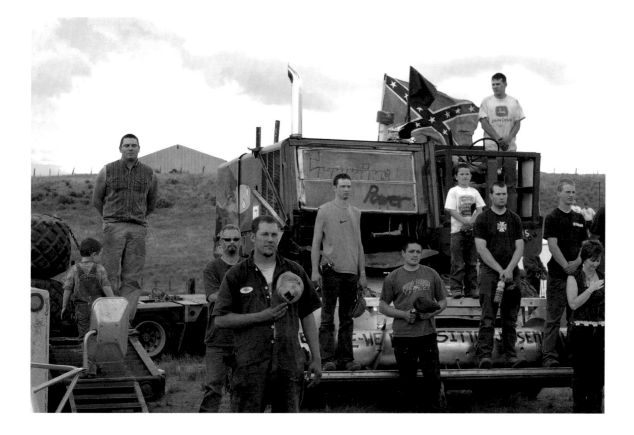

71. (*opposite*) Skip, owner of Slim's, at the café door in Lind.

72. (*above*) The Pledge of Allegiance at the Demolition Derby.

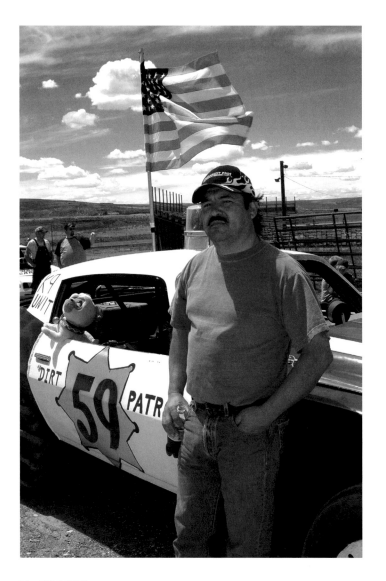

73. (*left*) Tony Garcia, winner of the demolition car race that precedes the Combine Derby.

74. (*opposite*) Mike Wilson and the boys, the crew for an entry in the Combine Demolition Derby.

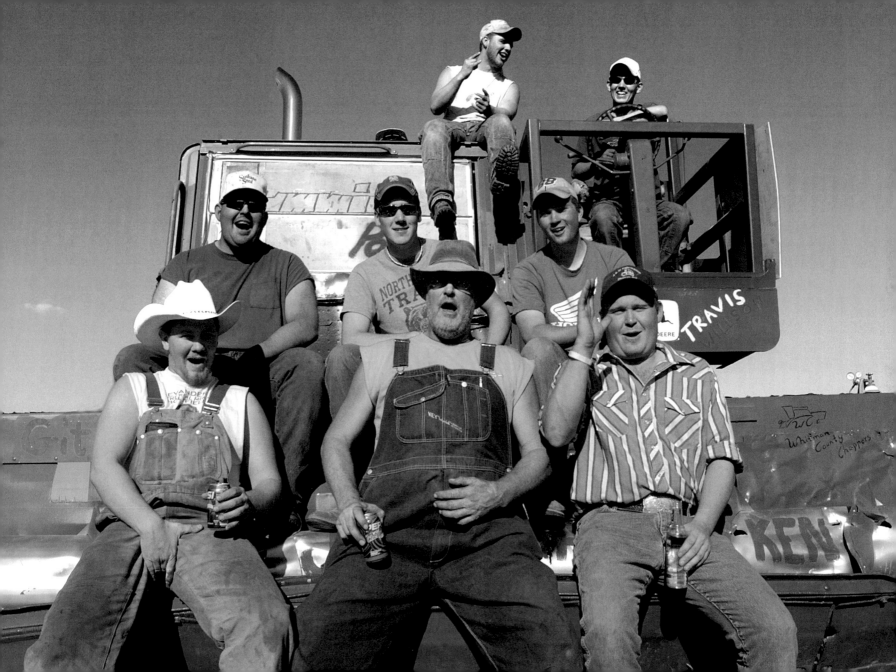

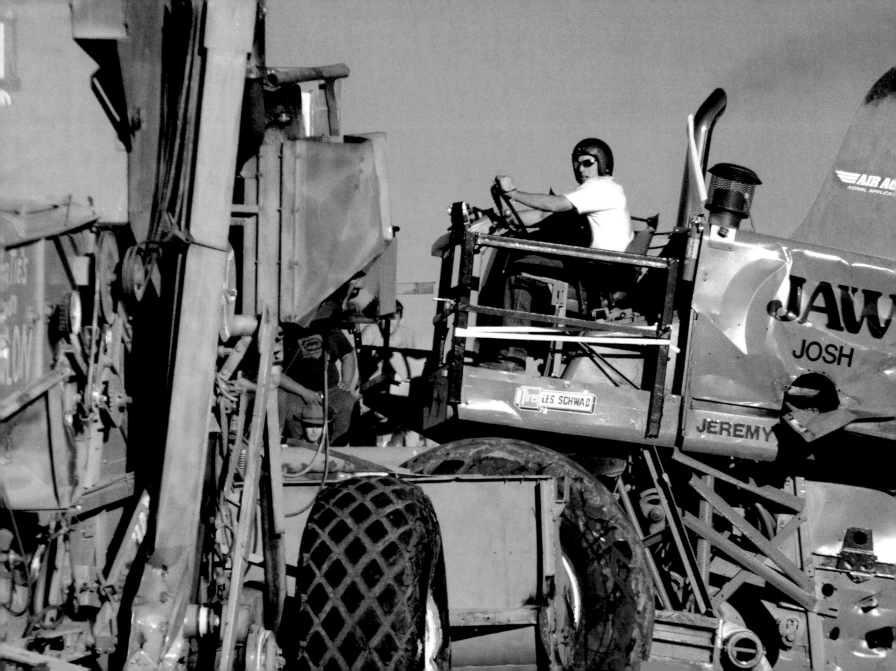

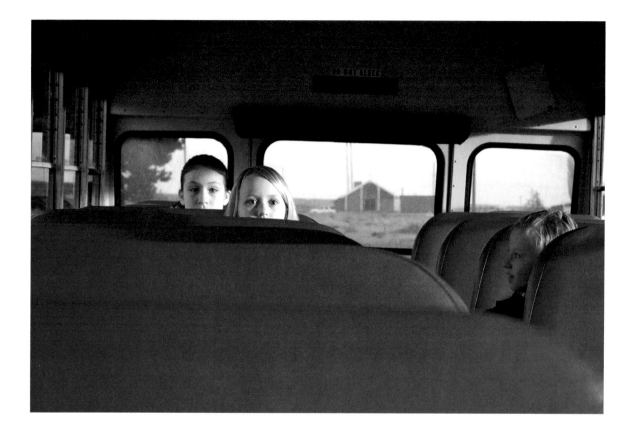

75. (*opposite*) Josh Knodel pilots the combine named "Jaws" in the Demolition Derby.

76. (*above*) Busing Washtucna schoolchildren to Lind: the declining population in the wheatlands has compelled towns to combine their schools.

77. (*above*) A show horse, farmland style, at the Wheatland Community Fair in Ritzville.

78. (*opposite*) Tara Rattray, Miss Rodeo Othello, rides in the Lind Grand Parade. Entries from far and near travel to add their hometowns' spirit to local parades.

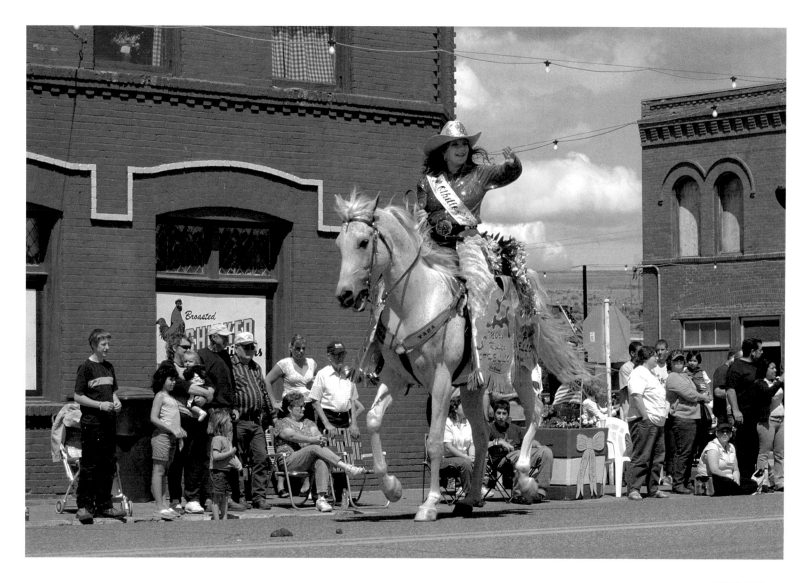

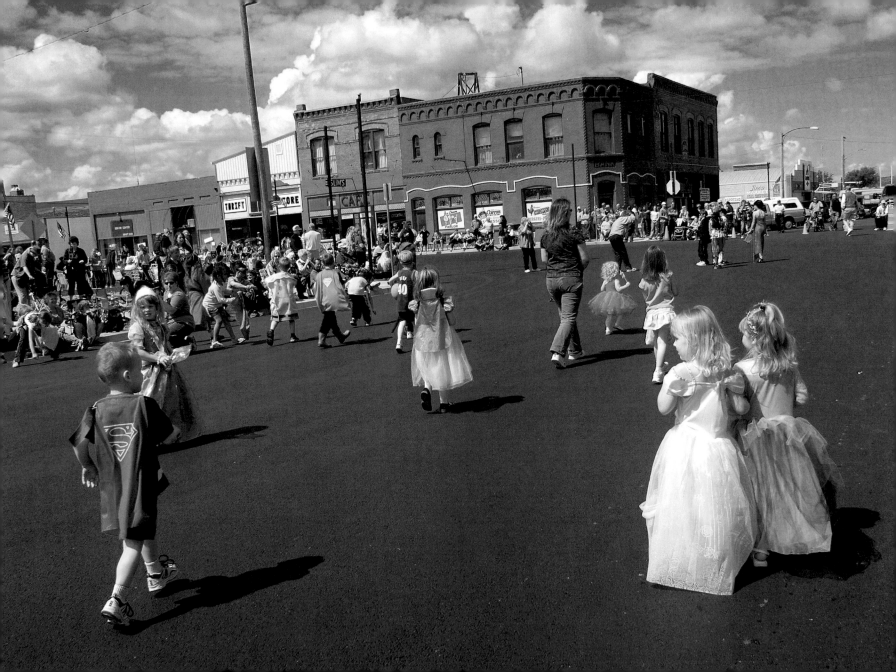

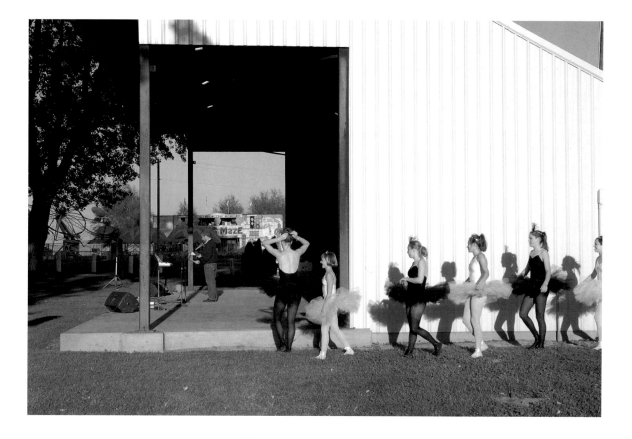

79. (*opposite*) Superman meets Cinderella at the Grand Parade in Lind.

80. (*above*) Ballerinas wait to perform at the Wheatland Community Fair. A feature of this annual event is an afternoon-long show of local talent in the bandshell, shaded by tall trees.

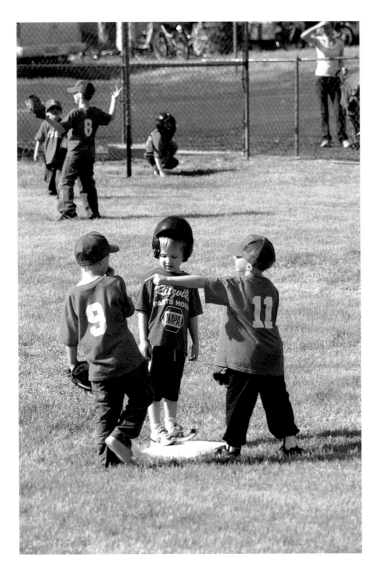

81. (*left*) The littlest league, Ritzville.

82. (*opposite*) Grand Parade judges, Lind.

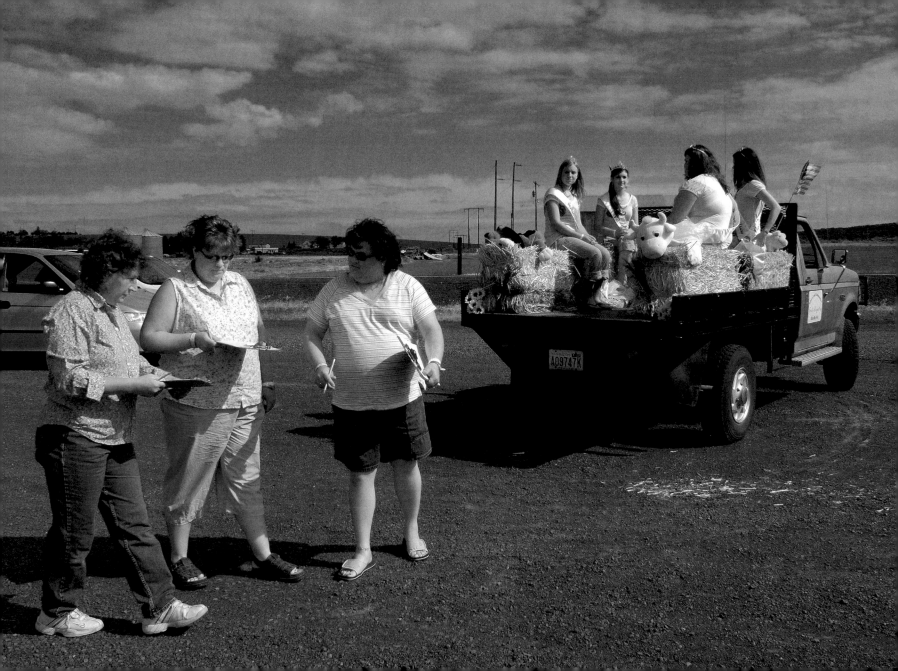

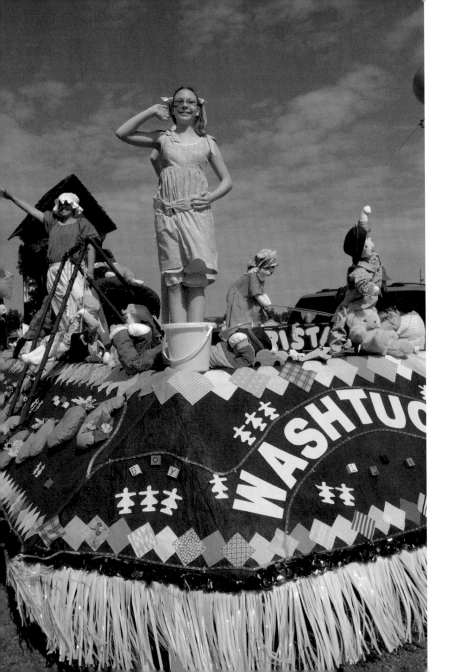

83. (*left*) "Old Lady in the Shoe," Washtucna's float in Lind's Grand Parade.

84. (*opposite*) Ritzville's float in Lind's Grand Parade.

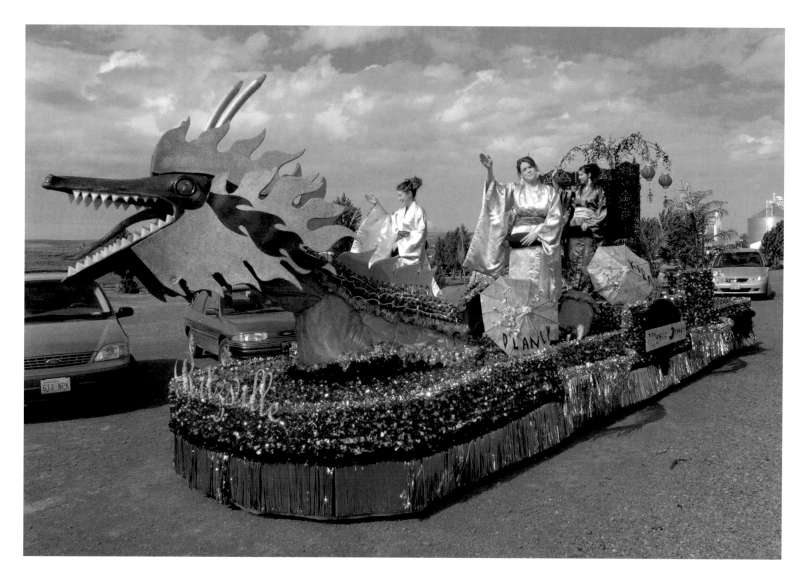

85. (*above*) John Hunt in his 1944 Weapons Carrier, July 4th, Washtucna.

86. (*opposite*) Ritzville Junior High School dance.

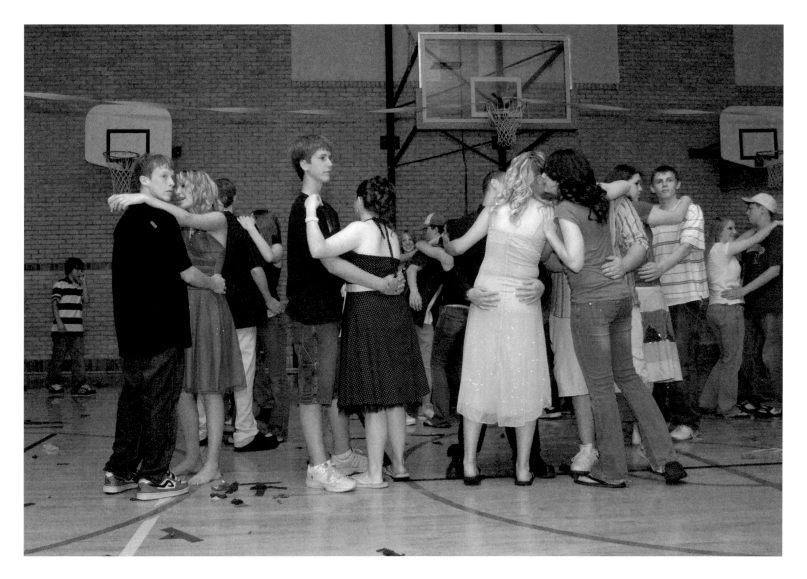

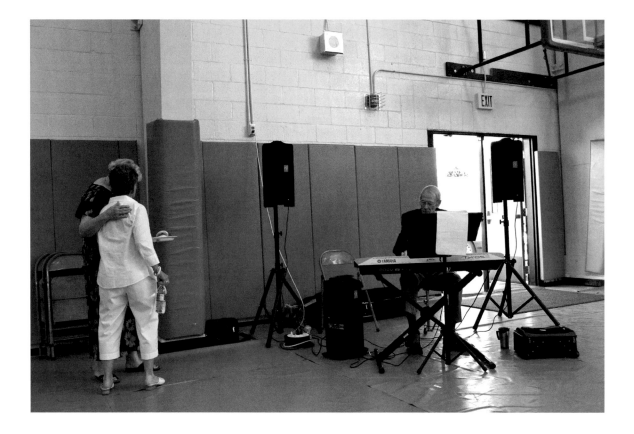

87. (*above*) Getting set for the reunion dance, Ritzville High School.

88. (*opposite*) Linda Kadlec, mayor of Ritzville and proprietor of Linda's Hair Salon, with one of Ritzville's architecturally more famous commercial buildings—now boarded up above street level—in the background.

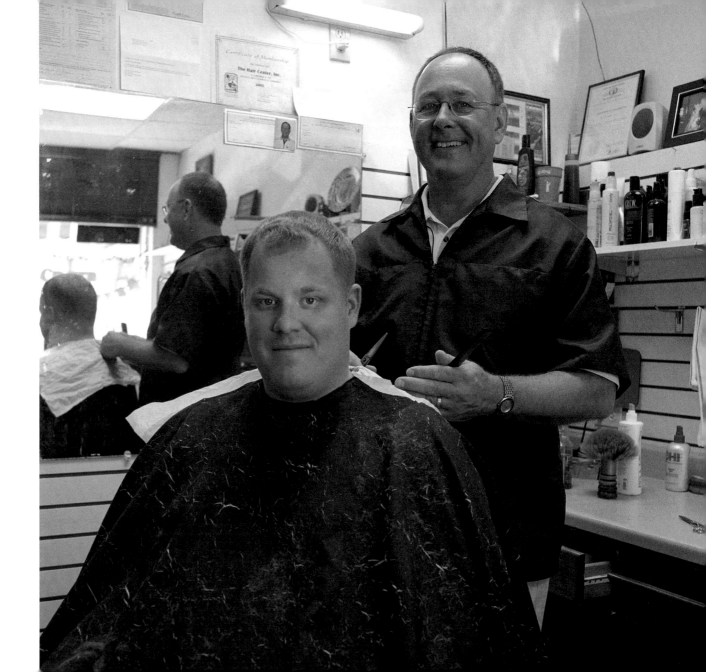

89. (*opposite*) Bruce H. Benzel, here with customer Jason, is the only barber serving the three-fourths of the county east of Othello.

90. (*left*) Neil Telecky, proprietor of the CSR–John Deere dealership in Ritzville.

91. (*right*) Dr. Valerie Eckley, at Lind's health clinic. The county's only full-range hospitals are in Othello and Ritzville.

92. (*opposite*) Ritzville police chief David McCormick.

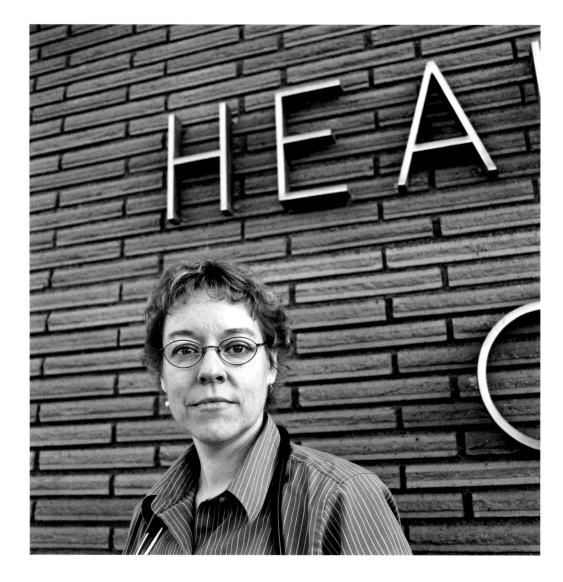

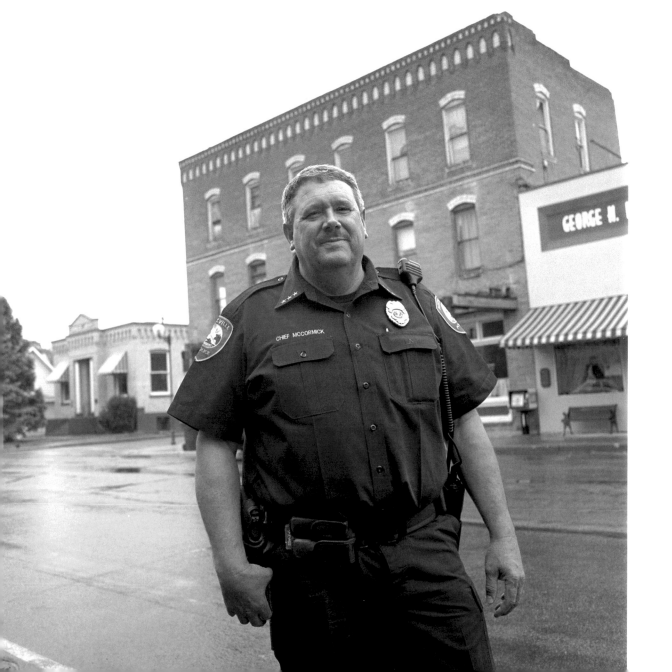

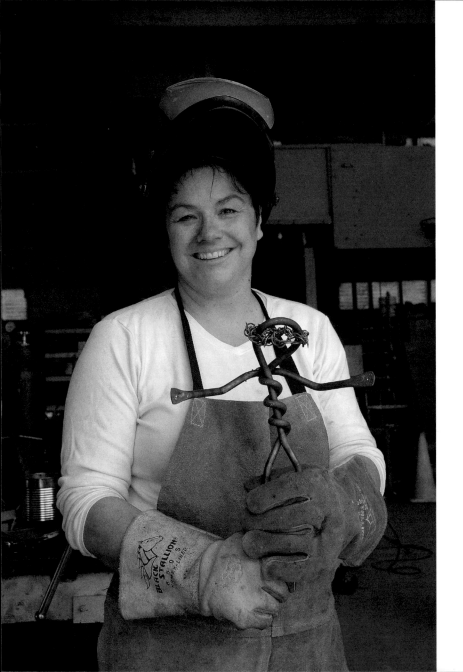

93. (*left*) "Blowtorch Annie" Smart, Lind-area farmer and metal sculptor.

94. (*opposite*) Fire District chief Andy Lefevre, Ritzville.

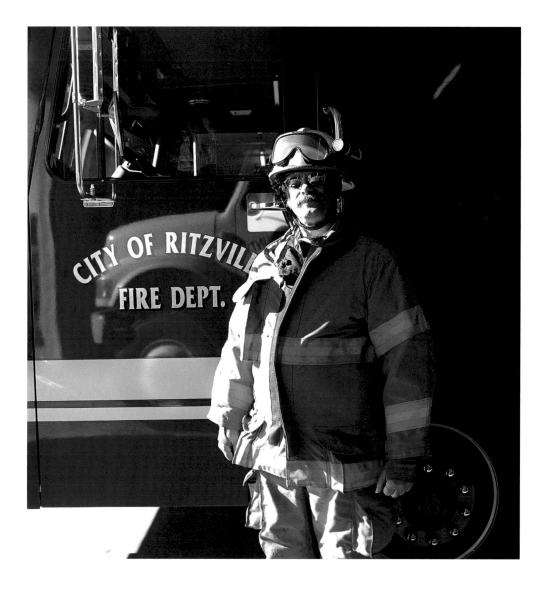

95. (*opposite*) Olivia Vela, branch manager of Sterling Bank in Othello.

96. (*right*) Roger Krug, Adams County's development analyst, and a former potato farmer and buyer who sometimes wears a pig mask in community parades.

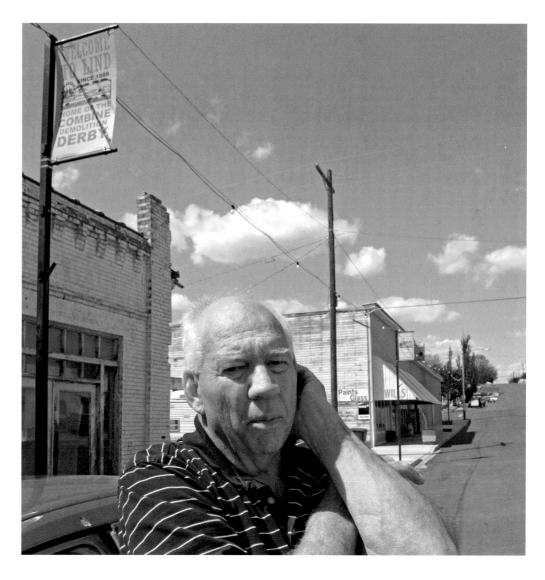

97. (*right*) "Junky," who salvages farm materials.

98. (*opposite*) Kirk Danekas, second generation funeral director, and the only one of that profession in the three-fourths of the county east of Othello.

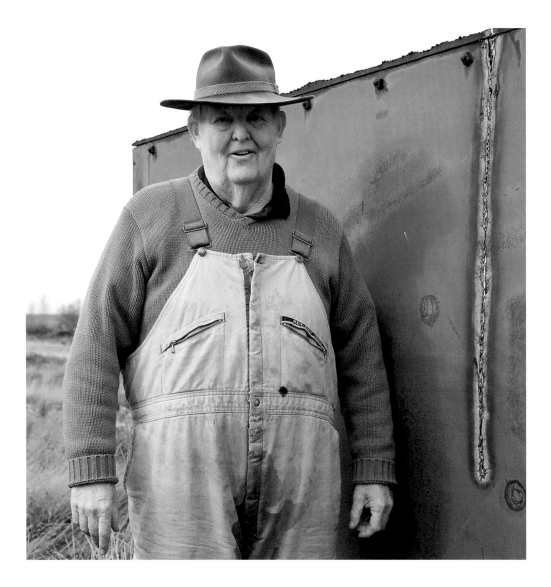

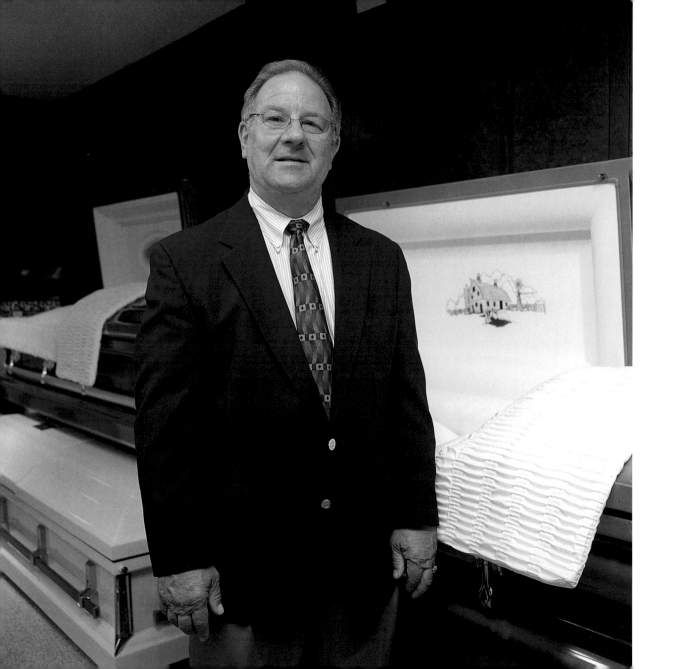

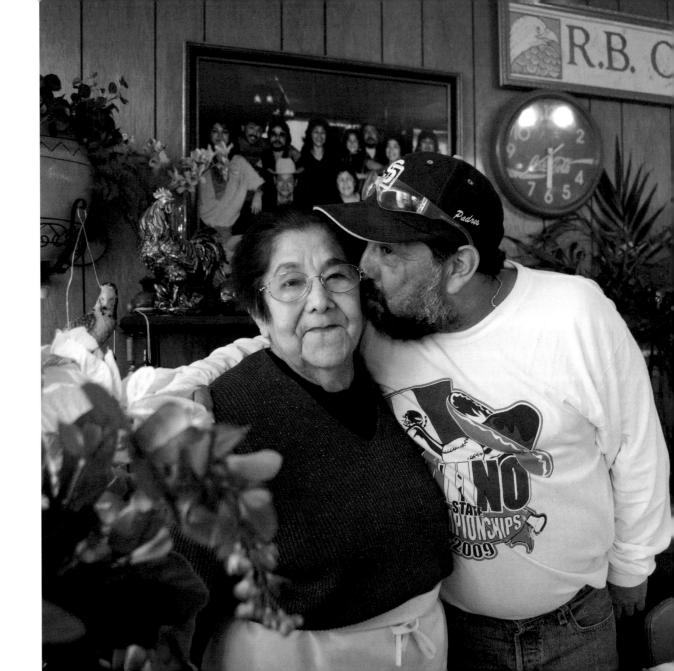

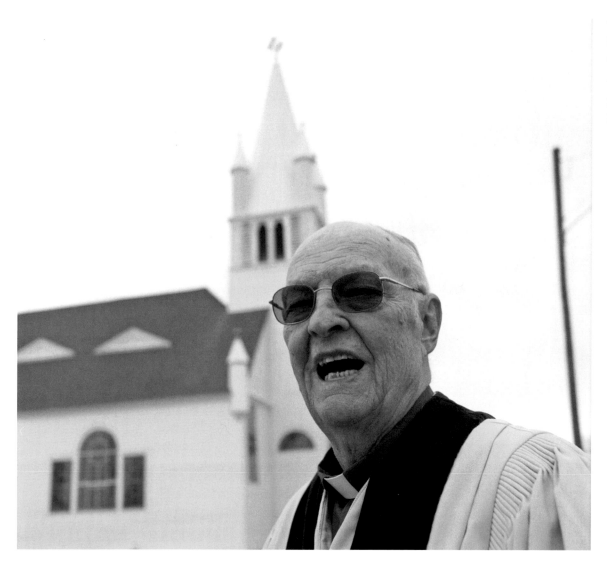

99. (*opposite*) Mrs. Elisa Benavidez, owner of Benavidez Café in Othello, and one of her sons, Manuel.

100. (*left*) The Rev. Ernest Sprenger, pastor of Zion Congregational United Church of Christ, Ritzville.

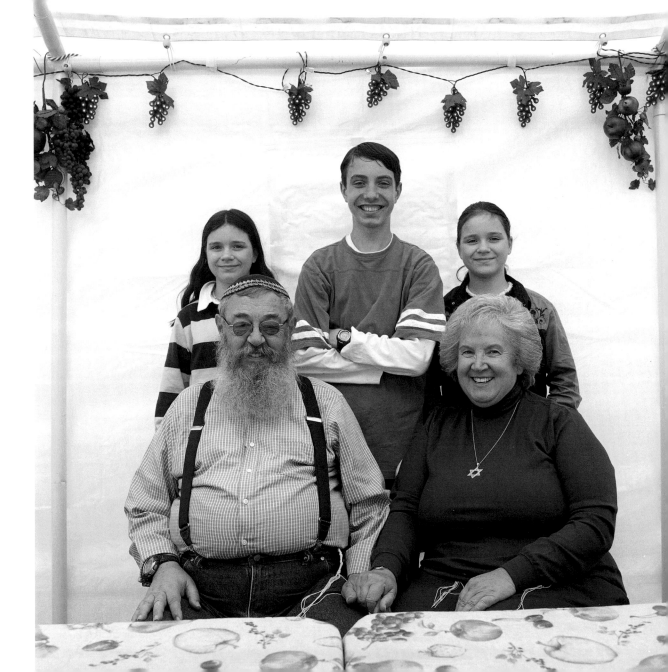

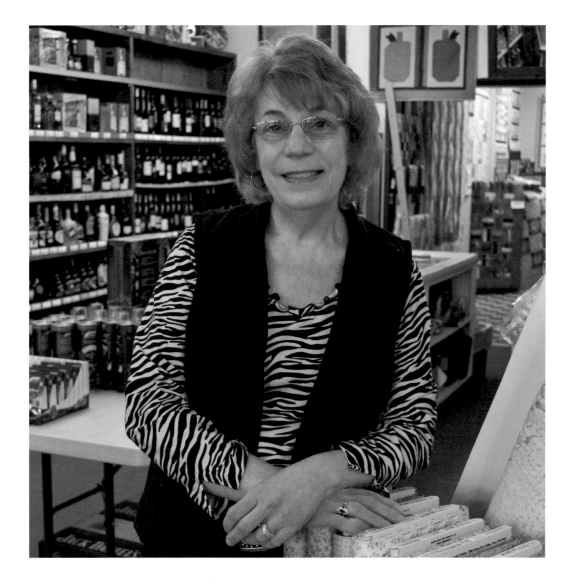

101. (*opposite*) The Boyers—Barry, Christine, and their adopted children—in a backyard Passover tent. The Boyers live by the tenets of Judaism but have not fully converted. Barry calls himself "an associate Jew."

102. (*left*) Mrs. Ami Danekas, proprietor of the liquors and quilt store, Ritzville.

103. (*right*) L. R. Keith, former morse telegrapher, presents living history at Ritzville's railroad museum, which occupies the decommissioned passenger terminal.

104. (*opposite*) Jerry E. Traver, Schwinn bicycles collector, Ritzville.

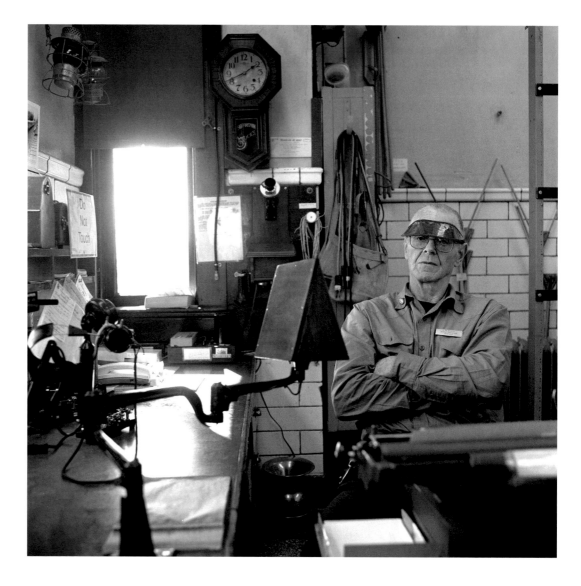

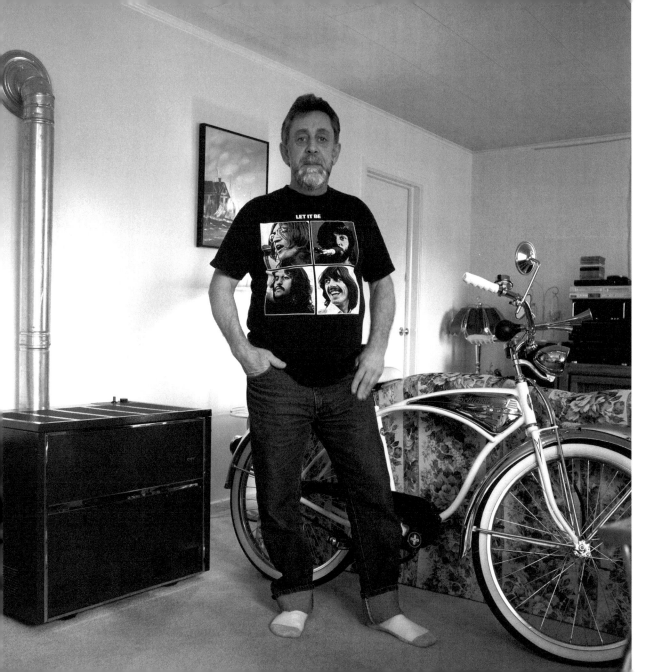

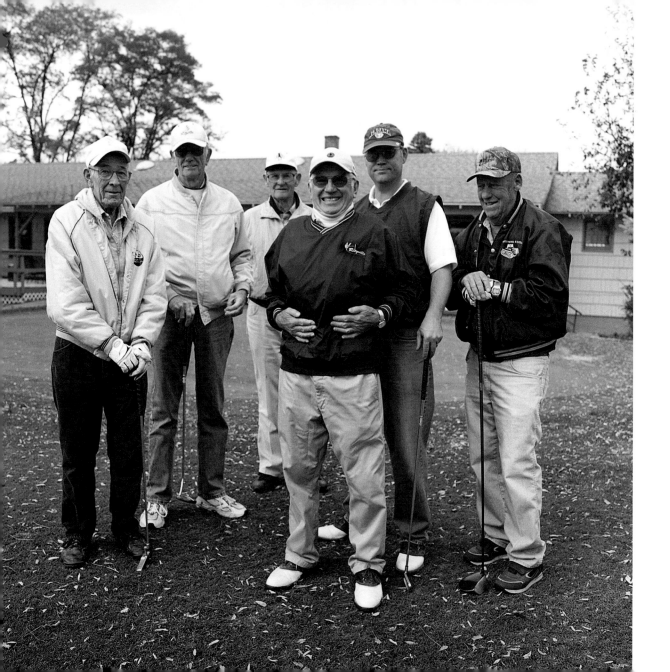

105. (*left*) Dr. W. D. Kragt, chiropractor, with golfing buddies, Ritzville. The town's offerings to tourists include a water park and this nine-hole golf course.

106. (*opposite*) West Main Avenue, Ritzville. In the town's heyday this street would have been busy with traffic, with parking on both sides.

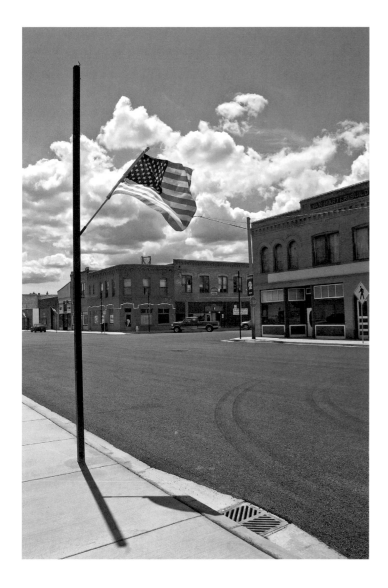

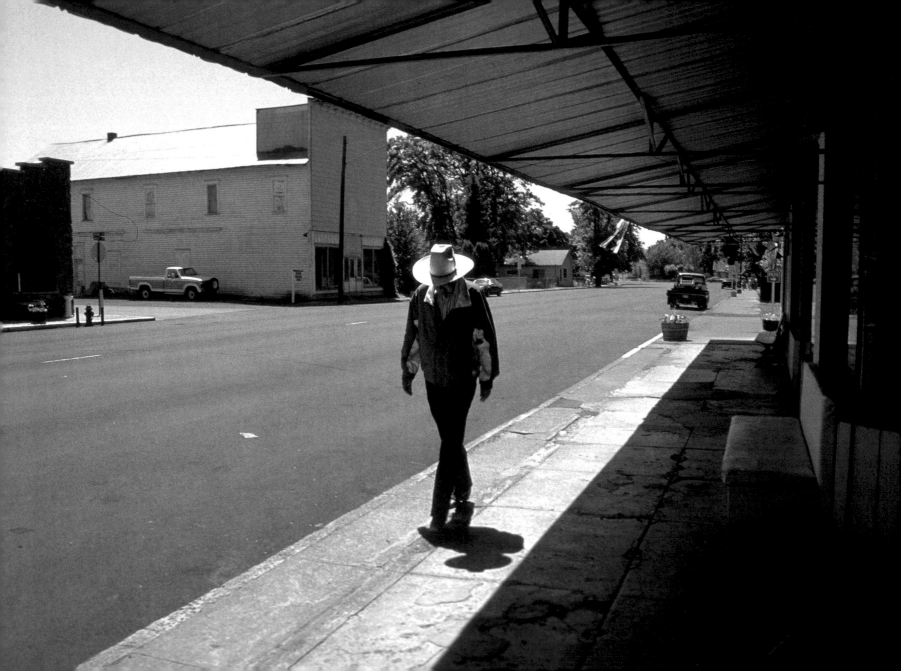